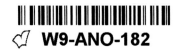
Photography With
Large-Format Cameras

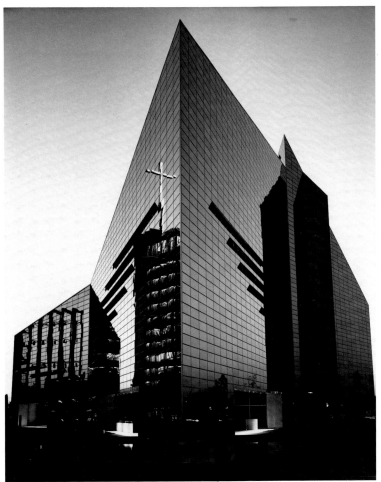

© Roger Vail

Photographer Roger Vail carefully chose the lens, viewpoint, and time of day to best emphasize the dramatic lines of this modern cathedral. This photo was made on 8 x 10-inch KODAK TRI-X Pan Professional Film.

Photography With Large-Format Cameras

Prepared by the editors of Eastman Kodak Company with the special writing contributions of Professor Leslie D. Stroebel and Jeff Wignall

Kodak Editor: Tom Hough

Technical Editor: James A. McDonald

Photo Research: Erv Schroeder

Photo Credits: Except where noted, all photographs by James McDonald and Larry Klippert. The editors gratefully acknowledge the assistance of the following: Calumet Photographic Inc., L.F. Deardorff & Sons, Kraft Inc., Polaroid Corporation, Wisner Classic Manufacturing Co.

Book Design: William Sabia, ES & J Art Incorporated

© Eastman Kodak Company, 1988

Professional Photography Division
Eastman Kodak Company
Rochester, NY 14650

Kodak Publication O-18
CAT 152 7894
Library of Congress Catalog Card Number 87-83296
ISBN 0-87985-476-6
2-91-AE Minor Revision
Printed in the United States of America

The Kodak materials described in this book are available from those dealers normally supplying Kodak products. Other materials may be used, but equivalent results may not be obtained.

KODAK, EASTMAN, EKTACOLOR, EKTACHROME, EKTAPAN, EKTAPRESS, EKTAR, ESTAR, ESTAR-AH, FLEXICOLOR, GOLD, KODACOLOR, KODACHROME, KODALITH, PLUS-X, ROYAL, SUPER-XX, T-MAX, TECHNIDOL, TRI-X, VERICOLOR, VERICHROME, and WRATTEN are trademarks.

Photography With
Large-Format Cameras

Extremely sharp and virtually grain-free, this elegant image imparts an almost luminous quality to this scene along the Merced River. Photographed by John Sexton on 4 x 5-inch KODAK TRI-X Pan Professional Film.

Contents

© John Sexton

© Michael Ruppert

1 View Cameras and Accessories

Modern View Cameras

Although the basic concept of the view camera has changed little since the early days of photography, refinements in design, materials, and manufacturing have brought today's large-format cameras into the realm of space-age technology. Offering precision adjustments of the lens and film plane, modern view cameras provide unparalleled control of the large-format image. With the aid of computers, designers have improved both the speed and quality of large-format lenses. And though we tend to think of the term system as synonymous with smaller-format cameras, the growing number of modular large-format cameras and the sophistication of available accessories has made the modern view camera second to none in flexibility. Yet for all of its glossy sophistication, it remains what it has always been: a tool for the creativity of the user.

Types of View Cameras: While they may vary considerably in price and features, virtually all view cameras can be divided into two basic design types: flatbed and monorail. Most of the early view cameras were flatbed cameras. Today, though the flatbed camera still accounts for about half of all large-format cameras made, the trend is toward the more flexible monorail design. Each type of camera has its own advantages and disadvantages. Choosing the one that's right for you is largely a matter of knowing what types of subjects you'll be working with and under what conditions you'll be photographing them.

Selecting 4 x 5-inch KODAK PLUS-X Pan Professional Film, photographer Michael Ruppert created this shot for a client's advertising campaign. Today's view cameras and films offer the opportunity for total control of the technical and artistic elements of a photograph.

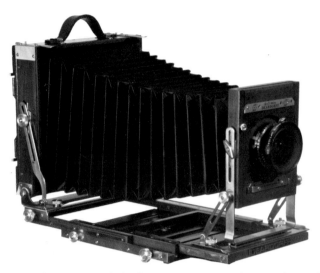

A typical 4 by 5-inch flatbed camera constructed of wooden and brass components.

All view cameras have three common components: a rear standard to hold the film, a front standard to hold the lens, and a flexible bellows to adjust the distance between lens and film. The way the standards are joined defines the type of camera.

Flatbed Cameras: In a flatbed camera, the two standards travel on a rectangular framework or "bed." The frame usually consists of a dual telescoping track that allows you to easily adjust the lens-to-film distance. Most flatbed cameras can be folded up into

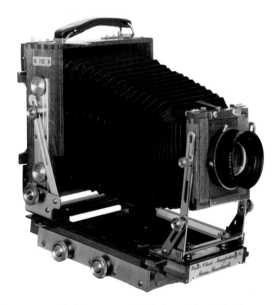

Also known as a field camera, this lightweight flatbed camera allows for rear rise and rear axis tilt adjustments.

a compact, self-contained box for carrying—and it is this very compactness that is the chief attribute of flatbed cameras. Often referred to generically as field cameras, flatbed cameras are light enough and portable enough to carry just about anywhere you'd take a small-format camera—a big advantage if much of your photography consists of landscape or location work.

Some flatbed cameras, particularly older models, may be limited in the amount of bellows extension or movement of the rear standard. However, most of today's flatbed cameras are designed with features and controls to match everything a monorail can accomplish. They simply achieve their results in different ways. When a certain adjustment isn't provided, a comparable effect can be duplicated by using a combination of other movements. In most situations in practical use, the more common constraints are those resulting from the limits of the lenses used.

Another potential limitation of field cameras is that not all of them accept interchangeable bellows—a major drawback if you do a lot of work with very wide-angle lenses (architectural photography, for example), because such lenses require a more flexible bag bellows. Again, however, many current designs allow for interchangeable and bag bellows, and any limitations may be more than compensated for by the camera's portability.

Press Cameras: Popular among newspaper photographers in the 1930s and '40s, the press camera is a variation of the field camera. Used ones can make an inexpensive first step into large-format photography. The British call them "baseboard" cameras because the bellows rides on a solid baseboard. Most press cameras were made in the 4 x 5-inch format, though some smaller formats were also sold. Because many press cameras have optical viewfinders or rangefinders in addition to a ground-glass, they can actually be handheld. In fact, some of the most memorable images ever recorded were made with handheld press cameras.

The rear standard in a press camera is fixed, and the front standard typically has extremely limited adjustments (usually allowing only a slight rise of the lens or a small degree of swing). One off-shoot of the press camera that's commonly used today is the technical camera. Intended primarily for use on a tripod, technical cameras allow a far greater degree of camera movement, and they can accomplish everything required of a view camera with most lenses.

Monorail Cameras: In a monorail camera, front and rear standards travel on a single tubular channel or rail. The great advantage of monorail cameras is their extraordinary flexibility and almost limitless combination of camera movements. Front and rear standards can be independently adjusted to the most extreme angles—usually far beyond the needs of most shooting situations. In addition, most monorail cameras are designed in modular fashion so that parts like standards and bellows and extension rails can be snapped in or out as easily as changing a lens on a 35 mm camera—some even allowing instant conversion from one format to another.

Monorail cameras are particularly popular with studio and industrial photographers whose photography frequently demands radical camera adjustments, or use of more elaborate accessories. The availability of a wide variety of accessories is a major advantage of the monorail design. In close-up work, for example, where a greater lens-to-film distance is required, you can add virtually unlimited bellows and rail extension.

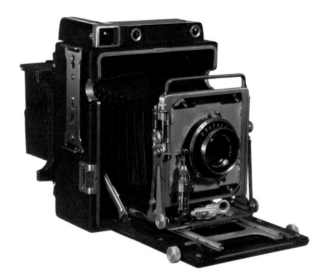

A venerable Crown Graphic press camera. The front standard allows for some limited adjustments—rise and fall, swing and tilt and some lateral shift.

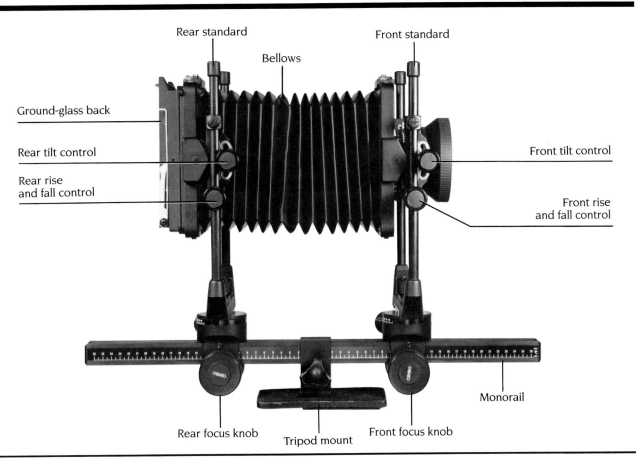

Rear standard

Bellows

Front standard

Ground-glass back

Rear tilt control

Front tilt control

Rear rise
and fall control

Front rise
and fall control

Monorail

Rear focus knob

Tripod mount

Front focus knob

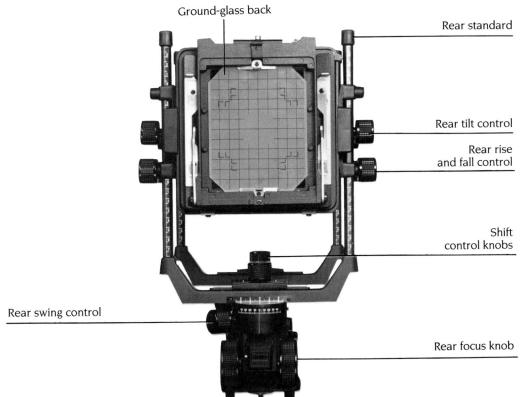

Ground-glass back

Rear standard

Rear tilt control

Rear rise
and fall control

Shift
control knobs

Rear swing control

Rear focus knob

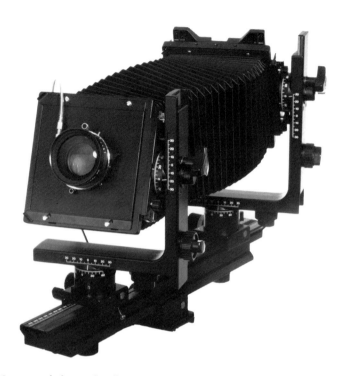

Stronger, lightweight alloys, and design innovations such as L-shaped standards, make some monorail cameras compact and flexible enough to use in the field.

Selecting a Format

Over the years, view cameras have been made to accommodate a variety of film sizes, from as small as 35 mm to as big as 20 x 24-inches and larger. In the early days of photography— before negatives were capable of great enlargement with ultrasharp results—cameras were designed to accept film the same size as the final print. For many of the early landscape photographers like William Henry Jackson or Eadweard Muybridge, this meant making images on 20 x 24-inch plates and then making contact prints from them. The prospect of carrying such a massive camera into the wilderness took more than a little devotion, but the images they produced have become historic treasures.

Needless to say, the advent of enlargers and improvements in film and optical technology have relieved the photographer of a considerable burden. Today, the two main view-camera formats in use are 8 x 10-inch and 4 x 5-inch; and though rapid strides in film technology are noticeably eroding the quality differences even between these two, each format does have its own virtues and benefits.

Which format is right for you? Choosing a camera on the basis of film size requires serious consideration of several factors. In many commercial applications (studio still lifes, for instance), the quality of reproduction will almost certainly be an important priority. Many product photographers prefer working with 8 x 10 cameras because such large negatives (and transparencies) allow far greater freedom in post-production techniques—retouching, stripping, making composites, etc. Industrial photographers, on the other hand, may prefer a 4 x 5 format camera because a wider variety of lenses are available in this size and because it is more portable and easier to use.

Cost too is always a factor. And though view camera prices tend to increase substantially as the format size increases, there is far greater difference in price among the brands within the same format. Precision, high-quality workmanship, and durability generally account for the differences. Lenses for 8 x 10 cameras are less plentiful and more expensive

The drawback to all of this technical freedom is mobility—or rather, lack of it. If you're working in a studio or at locations where bringing your equipment by car is no problem, a monorail camera shouldn't present any real handicap. But if you're traveling some distance by foot, the extra size (and usually weight) of a monorail camera can be a burden. And while all of those great accessories are fine in the studio, they can quickly become a nuisance to keep track of in the field. Also, because there are so many movements to consider in a monorail camera, they demand far greater

patience and attention to detail. Still, despite its inherent slowness, the flexibility of the monorail system camera should not be lightly dismissed —it is still the most versatile tool in photography.

Regardless of which type of camera you're thinking of working with, the questions of portability and convenience should be given serious and realistic consideration. Field and monorail cameras range from a few pounds to 20 or more pounds. And remember, where the camera goes, so must the film holders, the light meters, the camera case, and the tripod.

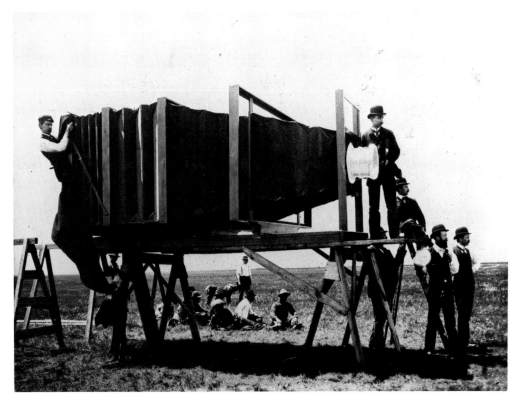

The largest camera ever constructed, the Mammoth camera was twenty feet long, weighed seven tons, and used a glass plate 8 x 4½ feet. It was designed for the Chicago and Alton Railroad to photograph a luxury train. (Archives of American Art, Smithsonian Institution, Photographer: George Lawrence.)

than lenses for smaller formats; and the size of the film you use has an effect on cost throughout your processing and printing system.

Multiple Formats: Fortunately for photographers who must produce photographs in more than one format, it is not necessary to purchase a completely separate view camera for each film size—there are alternative methods of adapting cameras to different formats. An obvious example is the interchangeability of lenses with the appropriate lens board adapters. If you foresee your work involving a wide variety of large-format work requiring frequent switching of formats, a more versatile camera system with a good selection of lenses and other accessories should be given priority.

Reducing backs, available for many larger view cameras, allow you to use smaller film sizes (for example using 4 x 5 with an 8 x 10 camera) by simply replacing the camera back. Some view cameras, called convertibles, use a more elaborate system that involves switching bellows and rear standards to change formats (from a smaller to a larger format or vice versa), but are more expensive because they require you to own two sets of bellows and a second rear standard.

A reducing back for using 4 x 5-inch film on an 8 x 10 camera.

For switching to an even smaller format, roll-film backs are also available and allow you to use 120-size roll film on your view camera. In essence, you can convert a 4 x 5 camera to a medium-format view camera. Roll-film backs are particularly useful since they offer the convenience of using roll films when full-format images are not required. Some brands of view camera also allow you to attach your existing 35 mm or 120 roll-film camera body directly to the back of your view camera.

A 120 roll-film back allows for the convenience of using roll films—and the versatility and flexibility of the view camera controls.

11

Switching formats does, however, complicate lens selection. Although it may be possible to use the same lenses (short focal length, normal focal length and long focal length, for example) on another format, they won't give you the results you might expect. A normal focal length lens for a 4 x 5 camera (about 150 mm) will be a short focal length lens for an 8 x 10 camera, but unless it has a wide-angle design, it won't have the covering power (see page 37) necessary to work properly with the larger film size if any camera movements are used. Conversely, although a short focal length wide-angle lens for 8 x 10-inch film will have more than enough covering power for 4 x 5-inch film, it won't function as a wide-angle because the focal length will be about the same as for a 4 x 5's normal lens.

Lens and Back Adjustments

An integral part of all view cameras, front and back adjustments can differ in design. Traditionally, the pivoting points for the swing and tilt movements of the front and rear standards have been placed in one of two locations—and traditionally photographers have disagreed over which placement is better. In some cameras, the pivots are located at the base of the standard near the rail or bed (called base pivots); in others the pivots are located at the horizontal axis of the lens or ground glass (called axis or center pivots). Some cameras have both.

One disadvantage of the base pivot is that the position of the image on the ground glass changes as you adjust the tilts, often requiring you to recompose the image. But perhaps the greatest difficulty of using base pivots is that tilting a standard alters the lens-to-ground-glass distance forcing you to refocus the image. If you're fine-tuning a composition by adjusting the tilts, this can mean continually refocusing the image until the final tilts are established. Because the lens-to-ground-glass distance doesn't change with center tilts, the focus point requires less adjustment.

A four-inch lens board with lens.

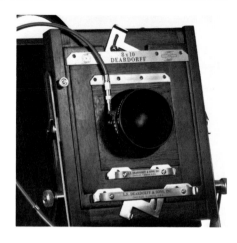

An adapter lensboard to accept smaller boards. This permits interchangeability of lenses among different formats.

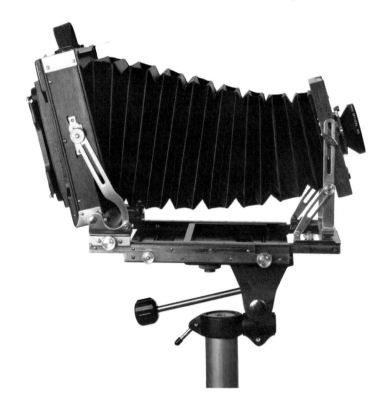

The back section of this camera pivots from a base axis (for tilts) and the lens-board frame pivots at the axis of the lens.

A disadvantage of the center tilt on camera backs is that if the back is tilted to a severe angle, the supporting arm of the standard can interfere with inserting and removing the film holder. Similarly, front axis tilts on some cameras can make lens operation difficult. On some cameras, a mechanical stop is added to prevent you from using such a tilt, but the restriction exists nonetheless.

Also, with many center tilt cameras, the same knob is used to raise and lower the standards and to tilt them—which makes it especially easy to throw one adjustment out of order while trying to set another. (Base tilts avoid this problem by using separate knobs.) There have been some solutions devised to conquer the problems associated with center tilts. Some manufacturers, for instance, use L-shaped brackets to hold the front and rear standards, which keeps one side free of possible obstruction and allows more flexibility of movement. The best advice is to try before you buy—and take the time to ask other view-camera photographers their opinions.

Different brands of view cameras also vary considerably in the degree of adjustment they allow. Generally, the more expensive the camera, the greater the flexibility. For example, maximum front or rear tilts may range from as low as 10 or 12 degrees to an "unlimited" amount (unlimited means that the lens or ground glass can be tilted anywhere within the limitations that the covering power of the lens will allow). Similarly, the amount of lateral shift can vary from none to several inches. So when you're comparing view camera specifications, don't forget that a view camera's maximum adjustments are only as good as your lens' ability to cover them. And as mentioned earlier, most cameras have movement capabilities that far exceed the requirements for normal photography.

Remember too, just as the amount of adjustment available on a camera is important, so is the ease of using those adjustments. Camera controls should be large enough to operate easily. They should loosen smoothly and lock firmly. If you photograph outdoors in cold weather, you'll have to be able to adjust and fine-tune all camera controls with gloves or mittens—not an enviable prospect if the knobs are tiny or hard to get at.

Compared to snapping a picture with a 35 mm camera, performing the exposure sequence with a view camera is a much more deliberate task. And it can get complicated fast. The sequence goes something like this: set up the camera, open the lens, compose the shot, set the camera adjustments, focus, take a light reading, set the working lens aperture, cock the shutter, insert a film holder, pull the dark slide, expose the film, and reinsert the dark slide. And remember, the ground-glass image is always upside down and reversed.

A Choice of Accessories

Camera and lens manufacturers have made considerable progress in simplifying view camera operation. The shutters on most modern view-camera lenses, for example, can be opened for focusing and closed with a separate lever without altering the shutter speed setting. Many older lenses require you to set the shutter speed to "B" to hold the lens open and then set the working shutter speed after the image has been composed. Several devices enable you to set the shutter speed and the f/stop from behind the camera. Another somewhat more sophisticated device automatically opens the shutter and diaphragm for focusing when a film holder is removed from the camera; the shutter closes and the lens stops down to the working aperture when the holder is re-inserted.

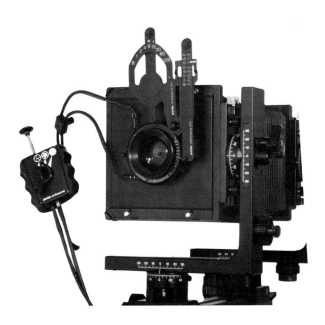

A remote shutter and diaphragm control allows you to open and close the shutter (for focusing), and adjust the shutter speed and lens opening, while working behind the camera.

For those who tire of craning their necks around trying to "correct" the upside down ground-glass image, there are reflex viewers that not only provide an upright image but allow you to magnify portions of the image for focusing (the magnifiers can be flipped out of the way for viewing the entire image at normal magnification). Because reflex viewers are part of a self-contained viewing hood, they also eliminate the need for a focusing cloth. You can rotate some viewers to 90-degree intervals—particularly helpful in situations where the camera position makes it awkward to view the ground glass directly (also helpful when working with art directors or clients inexperienced in viewing inverted ground-glass images).

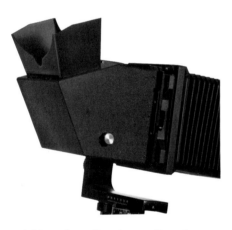

A binocular reflex viewer allows for viewing the entire ground-glass with both eyes. The usual inverted image is corrected by the reflex mirror.

An exposure meter with a probe to take spot readings directly from the ground glass simplifies exposure readings. With related metering accessories, you can calculate exposure for multiple spot (continuous or strobe lighting) readings, compensate for reciprocity effects, or set shutter speeds and apertures automatically. One of the benefits of exposure readings taken at the film plane is that they eliminate the need to calculate an exposure increase for the extended lens-to-film distance (see page 18) necessary in close-up work.

Mistakes in determining exposure or working by trial-and-error can be unnecessarily expensive and time-consuming. As an aid in previewing a setup, instant print film backs are available in both the 4 x 5- and 8 x 10-inch formats. Using an instant print film back allows you to produce test results for checking the image before you are committed to the final result. You can examine composition, lighting, and exposure—in black-and-white or color.

Such time- and work-saving accessories are tempting when you're first getting used to the slow pace of view-camera photography, but it's wise to buy and learn to use them one at a time. Mastering the camera itself requires patience and devotion so it's a good idea not to complicate that learning time with too many peripheral devices. And when you are considering different formats keep in mind that camera accessories cost more for larger formats—film holders, lenses and other accessories (including film) are all more expensive for the 8 x 10 format than for 4 x 5.

The probe for this film plane exposure meter can be placed anywhere on the ground-glass image. Because it reads the light coming through the lens, it automatically compensates for the lens extension and any filters that are used.

An instant print film back for a 4 x 5 camera.

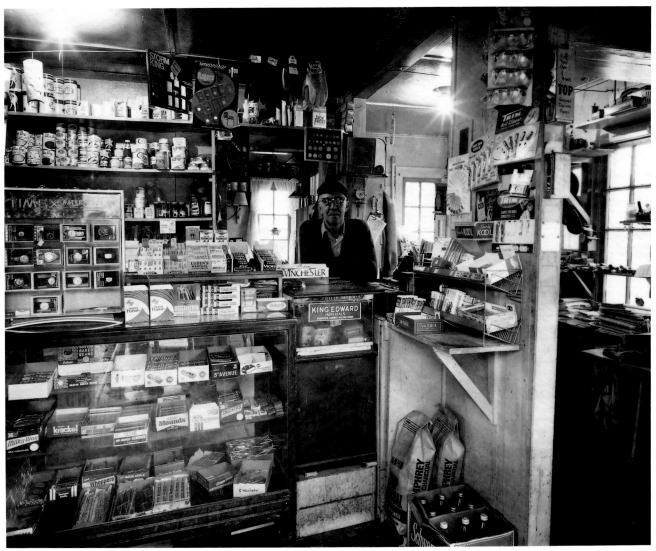

The rationale for using a larger format, even outside of the controlled environment of the studio, is clearly evident in the quality of the finished image. This photograph was made by Stephen Myers on 8 x 10-inch KODAK TRI-X Pan Professional Film.

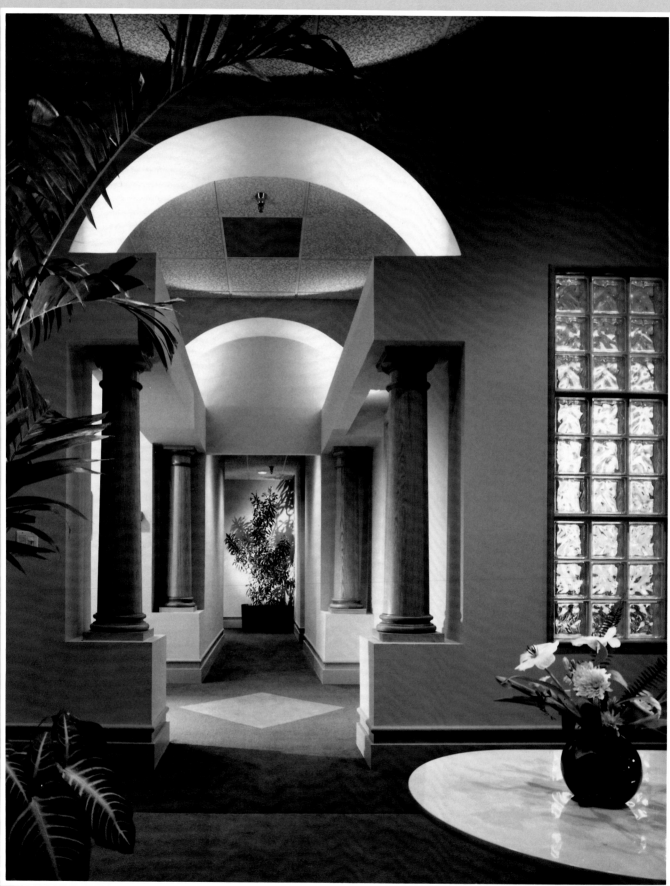

© Rick Alexander

2 View Camera Movements

The principal features that set view cameras apart from all nonadjustable cameras are the camera movements. In a nonadjustable camera, the relationship of the lens to the film plane is fixed and permanent; other than switching from one lens focal length to another, or changing your camera position, fixed cameras offer you little actual control over image manipulation.

A view camera, on the other hand, allows you to change virtually every aspect of the lens/film relationship, including: lens-to-film distance, vertical and horizontal displacement, and angular relationship. Because of this flexibility, you have almost limitless control over the ground-glass image. Image size, shape, sharpness, depth of field, and apparent perspective: You can enhance, change or exaggerate each. In addition, you can shift the placement of the main subject within the borders of the ground glass without having to move the camera, allowing you to fine-tune composition even after the camera position has been established.

Unfortunately, the fear of learning how to manipulate these many adjustments is probably the single biggest reason many photographers (even experienced ones) avoid learning to use a view camera. Learned one step at a time, however, operating a view camera becomes (like everything else you've learned that seemed hard at first) almost second nature. And once you've mastered the various movements and can anticipate their effects on your subjects, you'll have earned a degree of technical and creative image control that no other camera can equal—and few photographers share.

The demands of architectural photography require the versatility and precise image control that are the hallmarks of the view camera. Photographer Rick Alexander used a 90 mm lens on a 4 x 5 camera for this interior shot.

The basic view camera movements are:

- Changing the distance between the lens and film.
- Lowering and raising the front and rear standards.
- Laterally shifting the front and rear standards.
- Tilting and swinging the rear standard.
- Tilting and swinging the front standard.

As mentioned earlier, not all cameras have all of these movements (or offer the same degree of adjustment), but because there is some redundancy, the absence of one adjustment is generally not critical. In most cases, the effect of any one adjustment that is not provided for can be duplicated by combining other movements.

Lens-to-Film Distance

Focus: The most basic view camera movement is the bellows adjustment —changing the distance between lens and film. The primary function of adjusting this distance is to allow you to focus the image. By gently sliding the front or rear standard forward or back, you can find the lens' critical focus for a particular subject plane. However, while you can focus most view cameras by adjusting either the lens or the ground glass, focusing with the rear standard is usually preferable since the distance from lens to subject (and therefore the subject's magnification) can change dramatically when the front standard is moved. Many view cameras have both "rough" and "fine" focusing adjustments, the latter allowing you to make critical focusing adjustments after the main focus has been set.

Focal Length: Another important function of a variable lens-to-film distance is that it allows you to use lenses of different focal lengths. A view camera lens can only be focused at infinity if the maximum bellows draw is at least equal to the focal length of the lens you're using. The longer a lens' focal length, the longer the bellows that's needed. An 8-inch lens, for example, must have at least an 8-inch bellows to focus on infinity. Similarly, if you were to change to an even longer focal length lens, the bellows would have to extend to cover its focal length—you can't focus a 12-inch lens on infinity with only 8 inches of bellows.

Shorter focal length lenses require a shorter bellows draw, but this can be a problem if the bellows is stiff and won't compress enough to focus the image or if it resists the necessary camera movements. You can usually solve this problem by mounting the lens on a recessed lensboard, or if the camera allows, by substituting a bag bellows for the conventional accordion bellows.

To obtain critical focus, examine the ground-glass image with a four-to-six power magnifier as you adjust focus with the *rear* control knob. The focusing cloth which would normally cover the back of the camera has been moved aside for this picture.

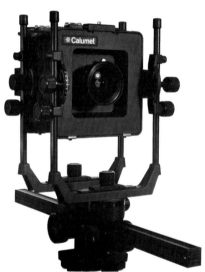

Short focal length lenses frequently require recessed lens boards that allow positioning the lens close enough to the film for proper focus.

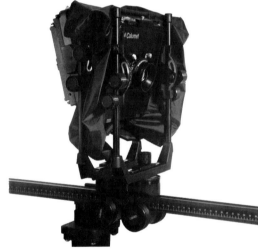

Replacing the conventional bellows with a supple, lighttight bag bellows unit allows for a wide range of adjustments when working with short focal length lenses.

Image Size: Bellows adjustment also affects image size on the ground glass. Because the lens-to-film distance must increase as the lens focuses on closer subjects, moving closer to get a bigger image is limited by the extension of the camera bed and/or the bellows for a given lens. For example, to achieve a 1- to -1 scale of reproduction, the lens-to-film distance must be two times the focal length. For an 8-inch (203 mm) focal length lens, the lens-to-film distance would have to be 16 inches (406 mm).

You can also get a larger image size by switching to a longer-focal-length lens. For distant objects, image size is directly proportional to focal length. With the camera in a fixed position, substituting a 16-inch focal length lens for an 8-inch lens would double the image size. Again, the length of the bed and/or bellows will dictate how long a focal length lens you can use—and thus the maximum image size of a distant subject. See chapter 3 for more information about lenses.

Rising and Falling Movements

The rising and falling adjustments of the front and rear standards have a comparable effect: they move the position of the image relative to the film without having to tilt the entire camera up or down. In effect, these movements place the film nearer to the edge of the circle of illumination (see page 37), or field, of the lens. Therefore, the extent of the vertical movement depends on the covering power of the lens (page 37). Definition and light intensity often falls off at or near the edge of the field, particularly with short focal length lenses.

In cameras with limited vertical adjustment, you can often use movements to augment one another when one alone does not give the desired result. For example, if the lens board cannot be moved down vertically from the central position, you can duplicate the adjustment indirectly by tilting the camera bed, or base, downward, and then restoring the lens board and back to the vertical position. Because the film and lens planes remain parallel, regardless of how much up or down shift you use, no change in the shape or geometry of the image occurs—only its relative position on the ground glass is altered. The *shape* of the subject changes only when the plane of the film and the subject are *not* parallel.

What does all this mean in terms of controlling the image? On a minor scale, such movements allow you to hone your compositions after the camera position has been set—a kind of in-camera cropping device. But more importantly, rise and fall movements allow you to control the convergence of vertical lines within a scene—in photographing a tall building, for example.

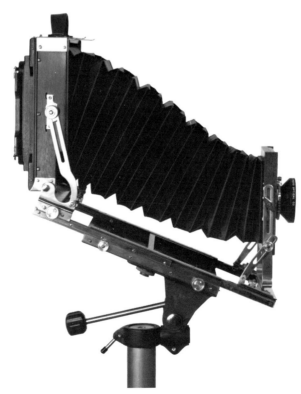

Combining a rear tilt with a front tilt—and changing the camera tilt—produces the same effect as a rise and fall adjustment.

If you've ever aimed a 35 mm camera straight up at a tall building, you know how dramatically the verticals appear to converge—the building seems to be leaning backwards in space. This effect is called keystoning, and it occurs whenever the film plane and subject plane are not parallel. (In real life, even though our eyes may detect the apparent convergence, our brain ignores it because we know from experience that the lines of the building are, in fact, parallel.) With a view camera, on the other hand, you can raise the lens (or lower the back) and take in the top of the building while still keeping the lens and film planes parallel to the building. The result is a tall building that goes straight up, with no convergence.

Of course, buildings aren't the only subjects you can correct—still-life subjects can be photographed geometrically correct using the rise and fall movements. Rising and falling can also be useful in eliminating distracting foregrounds where restricted mobility might prevent you from using a better vantage point. By raising the lens, for example, you might be able to include an overhanging tree limb as a compositional element at the top of the frame.

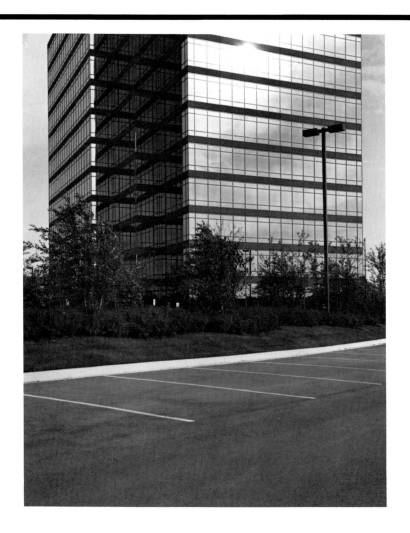

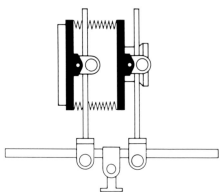

Starting with the camera level and perpendicular keeps the vertical lines of the subject parallel but cuts off the top of the building.

Lateral Shift

The lateral shifts of the front and rear standards have an almost identical effect as rise and fall, except that the image moves sideways on the ground glass rather than up and down. Again, as with the rising and falling movements, you must be concerned with the covering power of the lens and the loss of definition and illumination at the side of the negative nearest to the edge of the lens field. Be sure to examine the ground-glass image very carefully for vignetting.

You can use lateral shifts in two ways that have similar advantages to the effects of vertical movements. First, you can shift the lens board right or left to change the placement of the image on the ground glass after the camera position has been set. Second, you can use the back shift to control convergence—in this case, the convergence of horizontal lines in the subject.

Situations where these adjustments can be helpful would include a setup where it is necessary to photograph the front of a subject but a straight-on camera position is impossible or undesirable. In interior photography, for example, you might have to photograph a room with a mirror or other reflective surface in front of the camera. If you place the camera directly in front of the mirror, the camera will appear in the image. However, by setting up to one side of the mirror, with the lens board and back zeroed and parallel to the subject plane, the reflection will be eliminated. Then, to recenter the image *and* control the convergence of horizontal lines in the scene, shift the front and back laterally in opposite directions.

One important aspect to remember about both rising/falling and shifting is that while in many situations it may not seem to matter whether you move the front or rear standard, it is important to some degree. Moving the back of the camera (up or down or sideways) moves the image across the

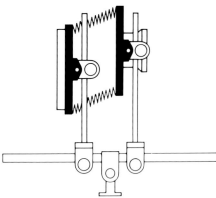

With the camera level and perpendicular, simply elevate the front lens standard (a rise adjustment) to bring the top of the building into view—this keeps the vertical lines parallel. The lens must have adequate covering power to prevent vignetting when using this adjustment.

ground glass, and it has no effect on subject shape or the camera's point of view. Moving the lens, on the other hand, does alter the camera's viewpoint slightly—the spatial relationship between near and far subjects changes as the lens moves. The shift in viewpoint may be minimal, but you should be aware that it is happening.

Swing and Tilt

In addition to moving up and down and sideways, the front and rear standards on most view cameras can also be tilted on both their horizontal and vertical axes. Rotation on the vertical axis is called "swing," and on the horizontal axis it's called "tilt." But unlike the vertical and horizontal sliding movements, swing and tilt do not have the same effect for the front and the

rear standards—in fact, in most cases the results are quite different. The most important difference between the two is that pivotal movements at the *lens* plane affect only image sharpness, while movements at the *film* plane change both image sharpness and shape.

Rear Swing and Tilt: The reason the swinging and tilting motions of the rear standard affect the shape of a subject is because such movements change the lens-to-film distance. If you've ever tilted one end of the paper easel under an enlarger, you've seen how drastically the geometry of the projected image can be altered: the image on the side of the easel that is closest to the lens becomes smaller and the image on the side farthest

away becomes bigger.

The change in image shape and size that results from angling the camera back is most obvious when the subject has well-defined parallel lines. As an example, if you were to position the camera so it was straight-on to a rectangular building with both the lens board and the camera back parallel to the front of the building, both ends of the building would be of equal height and the shape of the building would be correct on the ground glass. But if you were to swing the back of the camera so that it was no longer parallel to the front of the building, one edge of the ground glass would be closer to the lens than the other. The effect would be to change the building's shape, making one end look taller than the other.

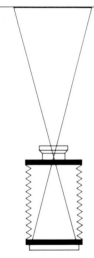

Top view
With all adjustments on the camera "zeroed," this twelve-inch square appears symmetrical. (The photographs represent the finished print, *not* the image on the ground glass.)

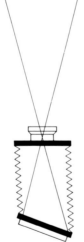

Swinging the rear standard of the camera clockwise makes the left side of the square larger.

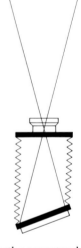

By swinging the rear standard of the camera counterclockwise, the right side of the square becomes larger (its image is formed farther from the lens).

You can visualize the change that rear swings and tilts will have if you remember this: objects on the ground glass that are closer to the lens will be smaller, and those farther away will be bigger. Also, tilting or swinging the back affects the film's relationship to the lens by changing the location of the plane of sharpness. As we'll see later, the area of sharpness can also be affected by stopping down the lens to increase depth of field, or by tilting or swinging the lens. Changing the lens-to-film distance with the swings or tilts can also drastically alter the amount of light reaching the film from the near and far points. Most lenses (even the best) show some illumination fall-off as the adjustment is made.

The most practical use of rear swings and tilts is to control the convergence of either vertical or horizontal subject lines (or both). As was discussed in the rising/falling section, for parallel lines in the subject to remain parallel in a photograph, the film plane must be kept parallel to the subject plane. However, controlling the convergence of parallel horizontal lines gets a bit more complicated when you're photographing a subject from an angle so that it shows two sides with parallel lines converging in different directions—in a three-quarter view, for instance. The problem is that when you swing the back to correct for the convergence in one plane, you exaggerate the convergence in the other.

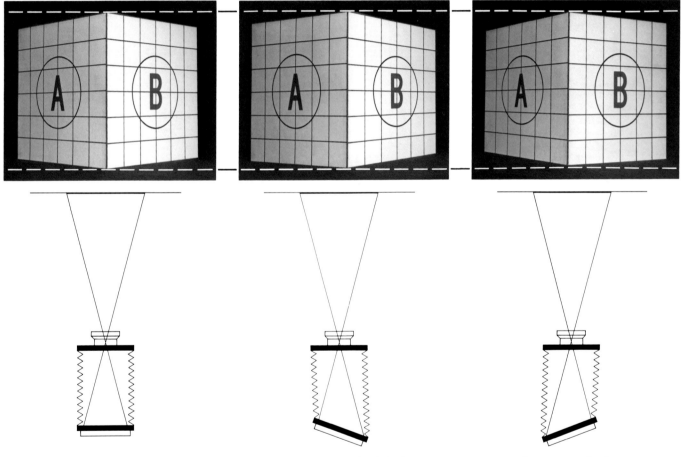

If you view the cube from the corner, and all camera adjustments are "zeroed"—both sides of the cube appear normal.

Swinging the rear standard clockwise decreases the normal convergence of the left side—and increases the convergence of the right side (the left side becomes larger).

Swinging the rear standard counter-clockwise decreases the normal convergence of the right side—and increases the convergence of the left side (the right side becomes larger).

Fortunately, a certain amount of horizontal convergence enhances the three-dimensionality and depth of the subject, so the effect may not be objectionable. If correction is desired, it's usually easier and more appealing visually to correct the plane that contains less convergence. In any case, horizontal convergence is usually not as noticeable as vertical convergence and is often overlooked. In fact, it's interesting to note that when a subject in which we normally expect to see some convergence (either horizontal or vertical) is perfectly corrected with camera movements, the corrected image can be more distracting than the uncorrected image.

Many photographers use the swinging/tilting back to exaggerate, rather than correct, the convergence of horizontal or vertical lines and thus enhance the illusion of distance (or height) within a scene. A long city block, for example, can appear to stretch even farther into the distance if you swing the back away from the dominant parallel plane—just as a tall skyscraper appears all the taller when the film plane is tilted out of its true vertical position.

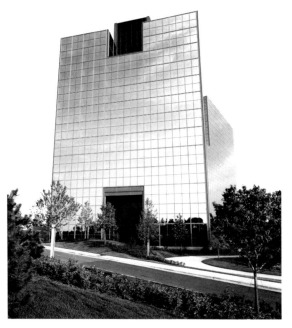

Tilting the camera upward so that the entire building can be seen produces the normal effect of convergence. Cameras with no front or back movements will produce a photograph similar to this.

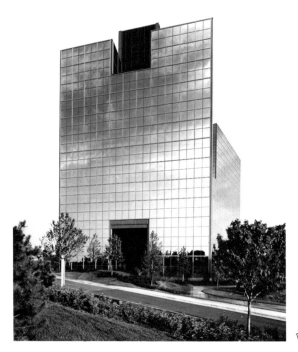

When tilting the camera upward, also tilting the camera back forward so that the film plane becomes parallel with the plane of the building corrects the converging vertical lines.

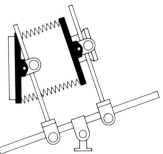

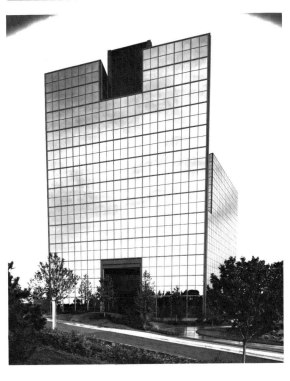

By tilting the camera back forward even more toward the building, the verticals become over-corrected. This causes a divergence of the building's lines (and possible vignetting).

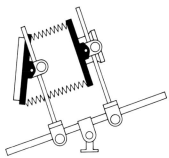

Finally, although it's easier to visualize the effect that tilting and swinging the camera back will have on a subject's shape when the subject contains distinct parallel lines, these movements will also noticeably alter more irregularly shaped objects. Apples and oranges, for example, can be strangely elongated, or a tall wine bottle shrunk down into a disquieting squat shape. Still-life photographers frequently use such adjustments to enhance the drama of their subjects—creating perfume bottles that soar toward majestic heights or silverware place settings that are elongated elegantly.

The effects of tilting and swinging the film plane on image shape can be summarized in two statements:

1. Tilting the film plane controls the convergence of vertical subject lines and image size from top to bottom.
2. Swinging the film plane controls the convergence of horizontal subject lines and image size from side to side.

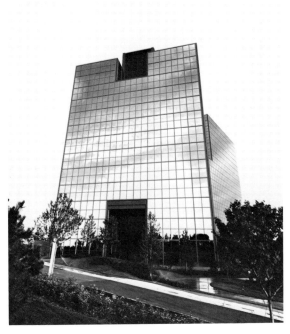

Tilting the camera back *away* from the subject plane exaggerates the convergence.

Front Swing and Tilt: The only reason for tilting and/or swinging the plane of the lens is to reposition the plane of sharp focus within a scene—the shape of the subject does not change. You can also control the plane of sharp focus by swinging or tilting the camera back, but as we've seen, any angular movement of the back standard also alters the shape of the subject.

Depending on where the lens pivots, the lens-to-film distance may or may not be altered. If the lens pivots on its horizontal axis, the lens-to-film distance doesn't change (only the angle of the lens' image changes). However, if the lens pivots at its base, there will be a definite change.

Visualizing the concept of specific zones of focus is easy if you remember that a lens can only focus sharply on one plane at a time. When a view camera is set up with both front and rear standards in their normal or zero positions, for example, the plane of sharp focus is a plane in space that is exactly parallel to them (just where in space that plane falls depends on where you've focused the lens). Now, if you tilt or swing the lens that plane of sharp focus moves. Tilt the lens forward and the plane of sharp focus also tilts forward (to an even greater extent than the tilt of the lens). Swing the lens left or right, and there is a similar swing in the plane of sharp focus. Since few subjects are perfectly flat and perpendicular to the lens axis (other than paintings or walls) this ability to change the angle of the plane of focus can be a very useful control for the view camera user.

Interestingly, if you stand facing the side of the camera and draw an imaginary line through each of the planes of the subject, lens, and film, you will find that these three planes meet along a common line. This relationship of the convergence of the three planes is known as the Scheimpflug rule—named after Theodor Scheimpflug, the Austrian surveyor who first discovered the principle in 1894. Scheimpflug observed that when these three planes met on a common line, the entire image was sharp from near to far, even at full aperture. Keeping this principle

With the aperture set at *f*/8, the plane of focus is very shallow when there are no camera corrections.

Tilting the front lens standard toward the plane of the table surface aligns the plane of focus with the subject. The *f*/8 aperture, and a slight rise adjustment, produces an image that is sharp from front to back.

When the subject is photographed at an angle, the shallow plane of focus at f/5.6 becomes apparent.

Without changing the aperture, swinging the lens plane parallel to the subject plane corrects the plane of focus. A slight lateral shift is required in the rear to center the image.

in mind can be very useful in finding the proper amount of lens and back tilt needed to give maximum sharpness for a given scene.

In one sense, a photograph made using the tilts and swings necessary to satisfy the Scheimpflug rule seems to reveal great depth of field. In the second image of the card table, for example, the plane of sharp focus extends from the near edge of the table to the far side. But don't confuse a long plane of sharp focus with great depth of field. Although the image is sharp from near to far, the depth of field is not equally wide throughout its placement in the scene. Technically, depth of field increases by the square of the subject distance. In other words, depth of field increases dramatically with increasing distance from the lens, and as you can see in the accompanying diagram, it actually forms a funnel-shaped pattern expanding outward from the camera.

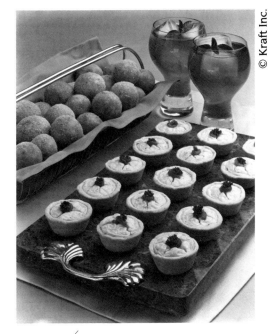

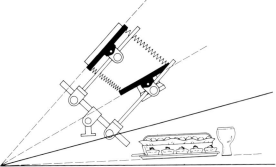

The maximum possible sharpness results when the planes of the subject, lens, and film meet along a common line. Notice that the area of sharpness (indicated by the solid lines) is not even—it expands as the distance from the camera increases.

In situations where you might consider swinging or tilting the camera back to control the plane of focus, keep in mind that the required direction of movement will be opposite to the direction of movement needed to correct the convergence of parallel lines. Therefore, use the back adjustments to control image sharpness only when the accompanying change in image shape isn't important (or when an exaggerated linear perspective is aesthetically acceptable).

When you want to control both image shape and the angle of the plane of sharp focus, you must use the back adjustments to control image shape and use the lens swings or tilts to control the focus. It's important though to adjust the back first and then the lens, since changing the back affects both image shape and focus; changing the lens board position affects only the focus.

One caution to be aware of with all camera movements—but particularly with excessive tilting and swinging the lens—is that such camera movements shift the lens axis away from the center of the film. As a result, the evenness of the image illumination on the film is affected. In extreme cases, or where the lens doesn't have adequate covering power, vignetting is also a potential problem. It's a good idea to check the ground glass frequently—particularly at the edges—when using lens tilts.

Reversing and Rotating Backs:
One last camera adjustment that's unique to view cameras is the revolving or reversing camera back. With a handheld camera, changing your composition from horizontal to vertical (or vice versa) means turning the entire camera on end. But with a view camera, you can simply rotate the groundglass. Some view cameras allow you to position the ground glass anywhere in a 360-degree revolution ("revolving" backs), while others can only be rotated to 90-degree intervals. Most backs stay attached during repositioning, but some models, particularly older field cameras, may require you to remove and re-attach the back.

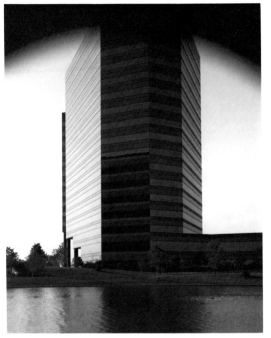

An example of vignetting resulting from excessive corrections or the limited covering power of a lens. Vignetting is not always apparent on the ground glass, especially when the aperture is wide open. Some lenses show a gradual loss of covering power with a drop-off in illumination towards the extremes of their coverage.

A rotating camera back allows you to produce properly aligned images without tipping or tilting the camera. To move the entire camera body generally calls for additional corrections.

Summary of View Camera Movements

A long bellows draw is required for long focal length lenses and for close-up work.

The full use of view camera adjustments requires a lens with adequate covering power.

The swing or tilt of the camera back alters the shape of the image and controls perspective.

The swing or tilt of the lens board controls sharp focus when the principal plane of the subject and the camera back are not parallel.

Horizontal and vertical lens board adjustments help to center the image on the film.

The revolving back adjusts the placement of the subject on the negative without the necessity of moving the camera.

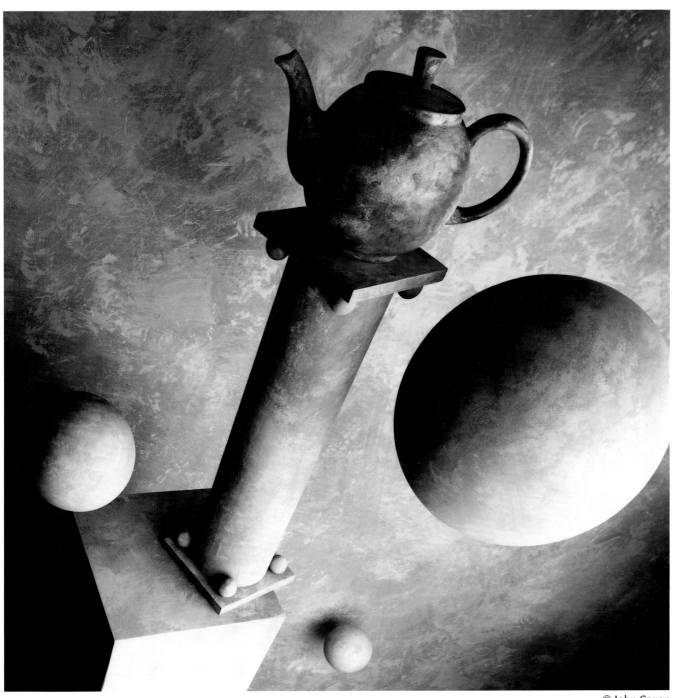

Photographer John Saxon used a combination of camera movements and a short focal lens to create this surreal image. The photograph was the offshoot of a commercial catalog assigment.

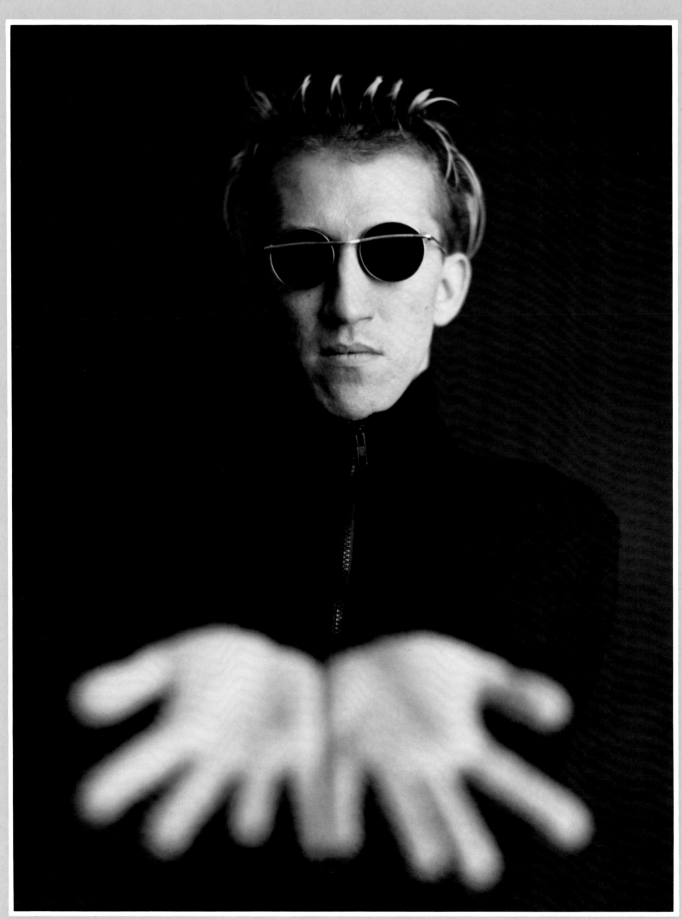

© Timothy Greenfield-Sanders, 1987

3 Forming the Image

The Camera Obscura

Cameras were around long before film. Although the date of the first camera is unknown, the basic principles of image formation were understood by Aristotle. Tenth-century Arab scholars wrote of a device that Leonardo da Vinci later described in great detail; called the camera obscura (Latin for dark chamber), this predecessor of today's cameras fascinated early scientists and artists. The original camera obscura was actually a room with a small hole in one wall. Light passing through the hole projected an image onto the opposite wall for a person inside the room to view. Though the image couldn't be fixed, it could be—and often was—traced by a freehand artist. Through the centuries, the camera obscura evolved into smaller, more portable versions, and by the middle of the 16th century, it included a simple lens that projected brighter and sharper images. Toward the end of the 17th century, the camera obscura had become a popular sketching tool for landscape and architectural artists—it offered them instant and perfect perspective. By examining the principles of pinhole imagery, then, we can also find the basic concepts involved in the formation of modern photographic images.

For us to see, or for a camera to make an image, there must be light. Whenever we look at or photograph an object that is not luminous or is not the source of the light, what we're seeing or recording on film is light reflecting from the object—not the object itself. Turn out the room lights and our surroundings disappear. Light is a form of radiant energy and the most important thing to remember about it is that it travels in straight lines. Whether it's traveling from the source to an object or reflecting off an object to our eyes (or a piece of film), it's traveling in straight lines.

The problem in creating a recognizable photographic image from those rays of reflected light arises from the fact that light bouncing off an object scatters in many directions and from all points of an object at once. Holding a piece of film in front of an apple obviously won't cause an image of the apple to appear on the film—there is no selectivity about which rays are striking the film or where they are striking it. As we see in the illustration, light from each point of the subject falls on all parts of the film simultaneously, interfering with the light from all the other subject points. The solution to this problem is found in the design of the camera obscura—using a small hole to regulate the rays of light reflecting from the subject.

By placing a light baffle with a pinhole between the object and film, it is possible to control which reflected rays strike the film and where they strike it. Because the baffle blocks the extraneous rays, only the light reflecting from one subject point and traveling in the exact direction of the pinhole will reach the film at one particular spot. The image is discernible because the light from each point in the subject is at a different angle to the pinhole, and each point is imaged at a different location on the film. This produces an almost point-for-point correspondence between the subject and the image—each point of light positioned by the geometry of straight lines.

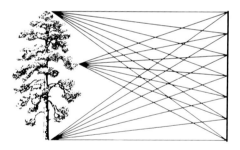

Light rays from the subject travel in a straight line to a viewing screen or film. No image is formed because the light from each subject point falls on all parts of the film and interferes with the light from all the other subject points.

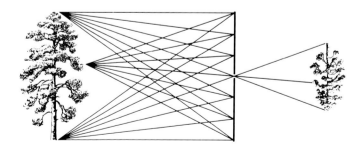

A pinhole limits the light reaching the film to a single path from each subject point; light rays from other points are at different angles so they cannot interfere. Because light travels in straight lines, the image is upside down and reversed.

Timothy Greenfield-Sanders used a turn-of-the-century Fulmer and Schwing camera, and very shallow depth of field, for this distinctive portrait of artist Mark Kostabi.

Each ray of light is characteristic of the subject's reflectivity and color, so the image reaching the film will have the visual characteristics of the subject; it will be light where the subject is light and colored where the subject is colored. And because light travels in straight lines, the image will be upside down and reversed from left to right.

Also, though a pinhole camera produces images that are relatively sharp and have almost infinite depth of field, it does not actually focus light. The only effect of changing the pinhole-to-film distance is to change the size of the image, not its sharpness. The size of the image is changed because altering the pinhole-to-film distance changes the angle of view reaching the film. For a particular film size, reducing the pinhole-to-film distance makes each subject image on the film smaller, and increases the angle of view; moving the film farther away enlarges the subject and reduces the angle of view. The pinhole-to-film distance and the size of the image are, in fact, in direct proportion to one another. And as we will see in the next section, this relationship is precisely the same as using longer or shorter focal length lenses.

Image size will also be affected by the subject distance. For a given film size, the size of the image is inversely proportional to changes in the pinhole-to-subject distance. In other words, if the subject distance is doubled, the image size is reduced to one half. Similarly, if the distance is tripled, the image size will be one third of the original image size.

Pinhole images have an appealing aesthetic quality, but the limitations on exposure and sharpness make the pinhole camera a less than perfect tool for most photographic work. The practical answer to better image formation is to replace the pinhole with a lens.

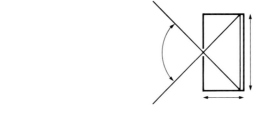

Angle of view is determined by the film size and the distance from the pinhole.

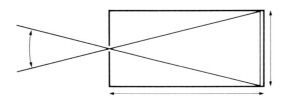

Increasing the distance from the pinhole decreases the angle of view.

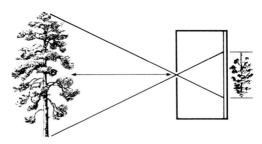

For a given film size, the subject distance determines the image size.

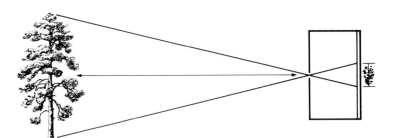

If the distance is doubled, the image size is reduced to one-half. Tripling the distance reduces the image to one-third its original size.

Lenses and Image Formation

Replacing a pinhole with a lens—even a very simple one—offers several distinct advantages in creating a photographic image. Perhaps most importantly, the larger surface area of the lens gathers more light, making the image brighter. Brighter images are easier to see (which was helpful even to Renaissance artists using the camera obscura), and from a photographic standpoint, exposure times can be shortened from several seconds (or longer) to fractions of a second. Also, unlike a pinhole image which cannot be focused, a lens can bend the light rays coming from a subject to focus them at a specific point and produce a much sharper image.

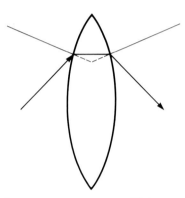

Refraction occurs as a ray of light enters an optical medium such as glass and slows down. All of the light rays except those that are perpendicular to the surface of the lens are bent.

When a ray of light enters a material with a greater optical density (such as glass or plastic), it slows down. This change in speed is called refraction. When the light enters the material along a path perpendicular to its surface, it continues in a straight line. However, if the light enters at an angle to the material, it is bent. This behavior of light is the underlying principle behind lens design. The amount of bending is determined by the shape, thickness, and the composition of the lens elements—and the angle of the rays as they strike the front surface of the lens.

Image formation by a lens is similar to, but slightly more complex than image formation by a pinhole. As we've seen earlier, each subject point reflects light rays in many directions. Those rays that strike the lens from a close subject distance form a cone—shown in the accompanying diagram as a triangle (a cross section of the cone). The ray at the center of the cone passes through the lens without bending, in the same way as the central pinhole ray passes directly through the pinhole. The lens focuses the other rays that form the cone so that they fall on the same point on the film as the central ray. The rays from all of the other subject points focus in different positions on the film in the same manner, creating the image. The drawing shows only the outer rays and the central ray of the cone. In reality, the cone from each subject point is full of light rays, each bent to focus at the same point on the film.

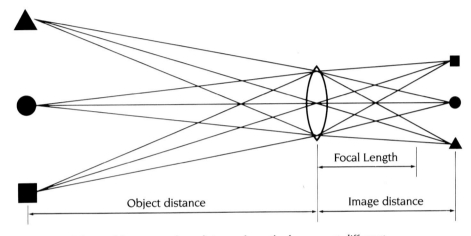

When subjects at a close distance from the lens are at different angles from the axis, the light rays from each subject point focus in different positions on the film, forming the image.

Focal Length: Light rays reflected from distant object points are essentially parallel as they enter a lens. If the lens is placed so that its axis is parallel to the parallel light rays coming from a distant point, the lens bends the light to form an image point, also on the axis. The distance between the lens and this image point (the principal focal point) is the focal length of the lens. This applies specifically to a thin lens whose thickness can be ignored for the purposes of our illustration. Technically, the focal length of a compound lens (such as the ones we use in photography) is the distance between the rear nodal point (or optical center of the lens) and the film when the lens is focused at infinity.

A lens is commonly classified according to the relationship between its focal length and the size of the film format with which it is being used. For a given format, the "normal" lens has a focal length roughly equal to the diagonal of the film. A 50 mm lens, for example, is considered normal for a 35 mm camera (though the film diagonal is actually 43 mm); an 80 mm lens is normal for 2¼ x 2¼; lenses around 150 mm are normal for a 4 x 5-inch format, and 300 mm is normal for 8 x 10 cameras.

In small-format photography it is common to refer to a shorter-than-normal focal length lens as a wide-angle lens, while a longer-than-normal lens is called a telephoto. However, the terms wide-angle and telephoto are more properly used to describe lenses of specific design. For example, a long focal length lens is not necessarily a telephoto lens. A true telephoto lens is designed so that the rear nodal point of the lens is located in front of, rather than within, the lens. The advantage of such a design is that the lens is more compact and it doesn't have to be extended its full focal length from the film plane to focus on infinity. This is particularly beneficial to view camera photographers since longer lenses of standard design can be cumbersome and require longer bellows extension. A similar differentiation can be made between short focal length lenses and wide-angle lenses; true wide-angle or wide-field designs have greater coverage than standard lenses. We'll

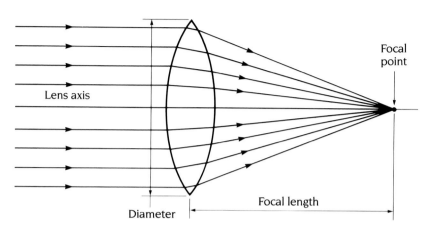

Light rays from a subject point at a great distance from the lens are essentially parallel. The lens bends the light rays to form an image point, or focal point, on the lens axis. The focal length is the distance between the lens and this point.

discuss coverage and other important lens characteristics in the following sections.

The light from objects that are at different distances in front of the lens are brought to focus at different distances (focal distances) behind the lens. The images of close objects are formed at focal distances that are greater than the focal length, and the closer an object is to the lens, the greater the distance is between the lens and the image. Image points that aren't on the exact plane of focus (the film plane) are less sharp because they are imaged as overlapping circles, not points.

Circles of Confusion: Each of these out-of-focus circles on the film is called a "circle of confusion." The farther away from the main point of focus an object is, the larger its circles of confusion will be on the film. Also, because the cone angle becomes greater at wider apertures, the circles of confusion are larger when the lens is used at large apertures. Stopping

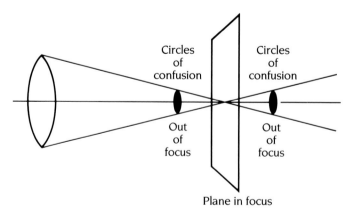

Out-of-focus circles on the film are called circles of confusion. When the circles are so small that they cannot be distinguished by the eye from points in the print or slide, they form an acceptably sharp image.

down the diaphragm to smaller apertures makes the circles of confusion smaller. When they are so small that your eye can't distinguish them from points in the final print or projected slide, the picture is acceptably sharp. In fine-focusing a view camera for critical sharpness, it's important to focus the image at the working aperture if possible, rather than at a wider one. The illumination will be reduced and a magnifier or loupe placed on the ground glass will be very useful for examining the image. The table below lists diameters of just acceptable circles of confusion for different film formats.

Diameters of Just Acceptable Circles of Confusion

| Format | Diameter | |
	Millimetres	Inches
35 mm	0.05	0.002
2¼ x 2¼ in.	0.08	0.003
2¼ x 2¾ in.	0.10	0.004
6 x 6 cm	0.08	0.003
6 x 7 cm	0.10	0.004
4 x 5 in.	0.15	0.006
5 x 7 in.	0.23	0.009
8 x 10 in.	0.33	0.013

The acceptable circle of confusion value generally used is 1/1000 of the focal length of the normal lens used for the format. For the most critical use, multiply the table values by 0.6.

Depth of Focus: The term "depth of focus" is occasionally mentioned in technical manuals and though it is of more concern to camera and film-holder manufacturers than photographers, understanding it will keep you from confusing it with the more practical considerations of depth of field (see page 39). Depth of focus can be simply defined as the range of distance at the image plane within which the circles of confusion are acceptably small. In other words, it is the distance that the film can be away from the optimum focus point of the lens and still produce acceptably sharp images. This zone usually extends an equal distance both in front of and behind the film plane. Aperture, subject distance, and film size all affect depth of focus.

Focal Length and Image Size: The focal length of a lens is not only important as a measure of the minimum bellows draw (lens-to-film distance) required to focus a lens at infinity, it also helps you to precisely determine image size—image size is directly proportional to lens focal length. Doubling the focal length doubles the image size; halving the focal length halves the image size. For example, if a 100 mm lens forms an image 1-inch high on a sheet of 4 x 5-inch film, a 150 mm lens will form an image that's 1.5-inches high and a 200 mm lens will form a 2-inch image, and so on (given a constant subject-to-camera distance).

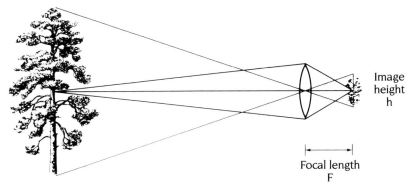

Image height h

Focal length F

At long object distances, the image height (size) is directly proportional to the lens focal length.

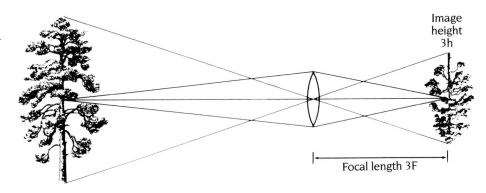

Image height 3h

Focal length 3F

When the focal length is tripled, the image height is also tripled.

And here we come to a rule that's of critical importance in understanding lens characteristics: *All lenses of the same focal length form images of the same size.* This is true regardless of the format. Therefore, whether you use a 100 mm lens on a 35 mm camera or an 8 x 10 view camera, the image size recorded on the film will be exactly the same for both formats. However, the total subject area included on the larger format will be far greater than that covered by the smaller format. In other words, the angle of view will change.

Angle of View: The angle of view of a lens is the angle formed by lines drawn from the rear nodal point of the lens (focused on infinity) to opposite sides of the negative area. In more practical terms, angle of view simply determines how much of your subject is included in the image when using a given film size and focal length.

Angle of view is a function of both focal length and film size. All lenses with the same focal length have the same angle of view when used with the same format. But with a given film size, *increasing* the focal length *decreases* the angle of view. The longer lens produces a larger image, so less of the subject area is included. On the other hand, a shorter focal length lens on the same camera will include more of the subject area and have a wider angle of view. Remember though, when the same focal length lens is used with different film formats, the apparent angle of view will change—a smaller film size will reveal less of the subject area and a larger film size will reveal more.

Lens manufacturers may list the angle of view for any given format as a single value based on the diagonal of the film. You may also see two values, such as 33° x 45°, that are determined by substituting the horizontal and vertical dimensions of the film format. Angle of view figures are important because they can be used to compare lenses within a given format, or as a comparison among different formats. For example, a 50 mm lens on a 35 mm camera has an angle of view of 40° (for the widest dimension, not the diagonal). To obtain approximately the same angle of view on a 4 x 5 camera would require a 165 mm lens, and with an 8 x 10 camera you would have to

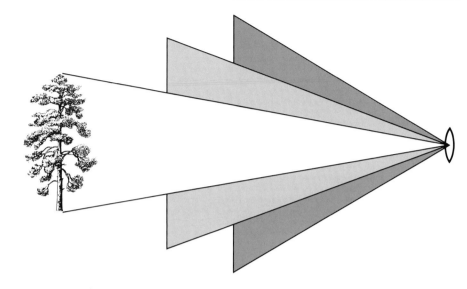

Angle of view changes with focal length. When the lens-to-subject distance remains the same, *increasing* the focal length *decreases* the angle of view.

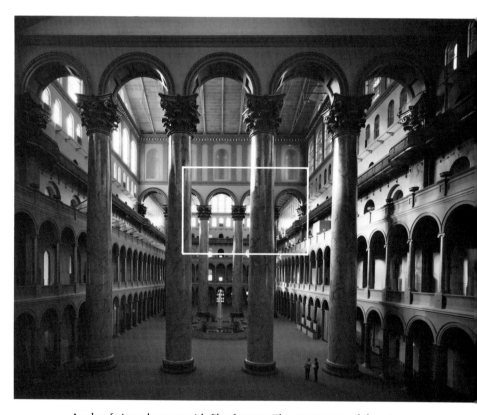

Angle of view changes with film format. The outer area of the picture represents the angle of view with a 4 x 5 camera using a normal lens. The inner area represents the much smaller view obtained if the same lens focal length is used on a 35 mm camera.

use a 350 mm lens. On the other hand, placing the 350 mm lens on the 35 mm camera produces an angle of view of less than 10° (with an image seven times larger than the image produced by the 50 mm lens).

Covering Power: Another important measurement of lens performance that is sometimes confused with angle of view is covering power, or angle of coverage. This is particularly important for view camera use. Every lens projects a cone of light that forms a circle of illumination at the film plane. However, not all of the image from the transmitted light is acceptably sharp and well-illuminated. There is a smaller inner area, the circle of good definition, which represents the useable image area, and the angle forming the circle of good definition determines the lens' angle of coverage.

For non-view cameras without front and back adjustments, the lens' covering power needs to be only great enough to fill the borders of the negative—the lens axis and the film plane are fixed perpendicular to one another. But with a view camera, the angle of coverage is very important and it determines how useful the lens will be. Because the shifting, tilting, and swinging adjustments may move the lens axis away from the center of the film, the position of the image circle is often shifted in relation to film. Unless the lens has enough coverage for these movements, the corners of the negative may be cut off or vignetted.

Covering power is affected by lens design, not by focal length or format. In other words, lenses of the same design but different focal lengths can have the same angle of coverage. Similarly, lenses of the same focal length but different design can have different covering power. For example, a lens designed as a "wide-field" type will have much greater coverage than a conventionally designed lens with the same or even shorter focal length. And changing formats won't change covering power. A lens that will allow some movements with a 4 x 5 camera probably won't have enough covering power to allow the same degree of adjustment with an 8 x 10 camera. On the other hand, a lens allowing only minimal movements with an 8 x 10 camera will permit far greater adjustment if used on the smaller format.

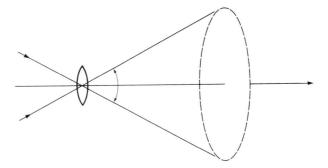

The total circular image area projected by the lens onto the image plane is called the circle of illumination.

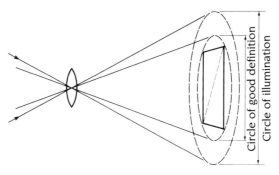

The angle forming the circle of good definition represents the angle of coverage of the lens (focused at infinity). For minimum coverage, the diagonal of the negative must be at least equal to the diameter of the circle of good definition.

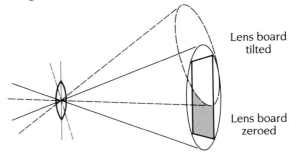

Tilting or swinging the lens board moves the optical axis off center. These movements require a lens with sufficient covering power to avoid vignetting as shown by the shadowed area in this drawing.

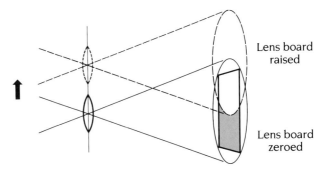

If the lens does not have sufficient covering power, vertical or horizontal movements of the lens board will also result in vignetting.

Changes in lens-to-film distance won't alter the angle of coverage, but the actual size of the circle of good definition formed at the film plane will increase as the lens is moved farther away to focus on close objects. Thus a lens of lesser covering power or shorter focal length can often be used successfully in close-up photography. Incidentally, stopping the lens down will increase coverage, so the angle of coverage for a lens should be given in reference to a specific lens opening. You can check with the lens manufacturer for this information.

Evenness of Illumination: If you critically examine large-format negatives made from a variety of lenses, you'll find that many are more dense in the center than around the borders. This is because the intensity of light at the center of a lens' circle of illumination is usually greater than at the edges. Common to all lenses, this effect is particularly noticeable with wide-angle and wide-field lenses. It's important then, to be more conscious of potential illumination "fall-off" when using lenses of very short focal length or lenses with great covering power. Though in most cases this loss of edge brightness is not of great concern, in some situations you may want to increase exposure slightly to compensate. You can then dodge the center area during printing to restore a uniform density.

The ƒ-Number System

One of the first technical lessons learned in photography is that shutter speeds and lens apertures work together to control exposure. Changing the shutter speed varies the length of time that the film is exposed to light; adjusting the aperture controls the intensity of the light that reaches the film. Lens apertures are marked as a series of numbers (called ƒ-stops or ƒ-numbers) that indicate the size of each diaphragm opening. There is an underlying mathematical logic to the aperture numbering system and understanding what these numbers mean in mathematical terms can be a great help in understanding how film exposure works.

The true ƒ-number assigned to each aperture setting is actually the ratio of the diameter of that particular aperture divided by the focal length of the lens. For example, if the focal length is 200 mm and the diameter of the aperture is 25 mm, the ƒ-number = 25/200, or 1/8, and is sometimes written as 1:8. In general use, however, the ratio is reversed and only the denominator of the fraction is used—we simply refer to the ƒ-number as ƒ/8.

Once you consider that an ƒ-number indicates the size of the aperture as a fraction of the focal length, it's easier to remember two significant points concerning ƒ-numbers:

1. As the actual size of the aperture in a given lens gets larger, the ƒ-number gets smaller. The ƒ-numbers are inversely proportional to each other; thus an aperture of ƒ/4 is much larger than an aperture of ƒ/32 or ƒ/45.
2. At the same aperture (ƒ-stop or ƒ-number) setting, all lenses produce images of the same brightness—regardless of focal length.*

Another important fact to remember about apertures is that each larger ƒ-stop doubles the area of the aperture and lets in exactly twice as much light as the next smaller one. Therefore, opening up the lens from ƒ/32 to ƒ/22 doubles the amount of light reaching the film. Similarly, closing or stopping down the aperture from ƒ/32 to ƒ/45 halves the amount of light reaching the film.

*In practice, variations in lens transmission may cause some variation in image brightness between lenses at the same aperture. Where exposure is critical, you may have to consider this factor.

Lens Diaphragm Settings

	ƒ-Numbers	Marked
Full	1.000	1.0
1/3	1.122	
1/2	1.189	
2/3	1.260	
Full	1.414	1.4
1/3	1.587	
1/2	1.682	
2/3	1.782	
Full	2.000	2
1/3	2.245	
1/2	2.378	
2/3	2.520	
Full	2.828	2.8
1/3	3.175	
1/2	3.364	
2/3	3.564	
Full	4.000	4
1/3	4.490	
1/2	4.757	
2/3	5.040	
Full	5.657	5.6
1/3	6.350	
1/2	6.727	
2/3	7.127	
Full	8.000	8
1/3	8.980	
1/2	9.514	
2/3	10.079	
Full	11.314	11
1/3	12.699	
1/2	13.454	
2/3	14.254	
Full	16.000	16
1/3	17.959	
1/2	19.027	
2/3	20.159	
Full	22.627	22
1/3	25.398	
1/2	26.909	
2/3	28.509	
Full	32.000	32
1/3	35.919	
1/2	38.055	
2/3	40.318	
Full	45.255	45
1/3	50.797	
1/2	53.817	
2/3	57.018	
Full	64.000	64

Controlling Sharpness

Our perception of image sharpness is based on a combination of subjective and measurable factors. One of the most important aspects of sharpness is a lens' resolving power, its ability to record fine detail. We can also measure contrast (differences in density) and acutance—a measurement of edge sharpness or *how rapidly* the change in density occurs across the border of adjacent details in the subject. Lighting, flare, granularity, exposure, and even development interplay to affect the image. The goal, of course, is to achieve an overall impression of clear, distinct detail. In working toward this goal, there are some useful camera controls that are available to us.

Depth of Field: Whenever a lens is focused on a specific distance, only objects at that exact distance will be sharply focused. Objects in front of and behind that point will be increasingly less sharp as they get further from the plane of sharp focus. But because the eye cannot detect very small degrees of unsharpness, a distance range extends in front of and behind the plane of sharpness that our brain also accepts as being sharp. This range of acceptable sharpness is referred to as the depth of field. In a landscape, for instance, if a tree at a distance of 10 feet and a barn at 30 feet mark the near and far limits of sharpness, the scene has a depth of field of 20 feet (though the boundaries of sharpness are rarely so exactly defined).

Image size and aperture size are the two primary factors affecting depth of field. With a view camera, you can also use the camera movements to enhance apparent depth of field. By applying each of these three factors independently or in combination, you have a remarkable degree of flexibility in manipulating an image's range of sharpness.

Howard Bond used KODAK Royal Pan Film and a No. 8 filter to photograph this tree in Rocky Mountain National Park.

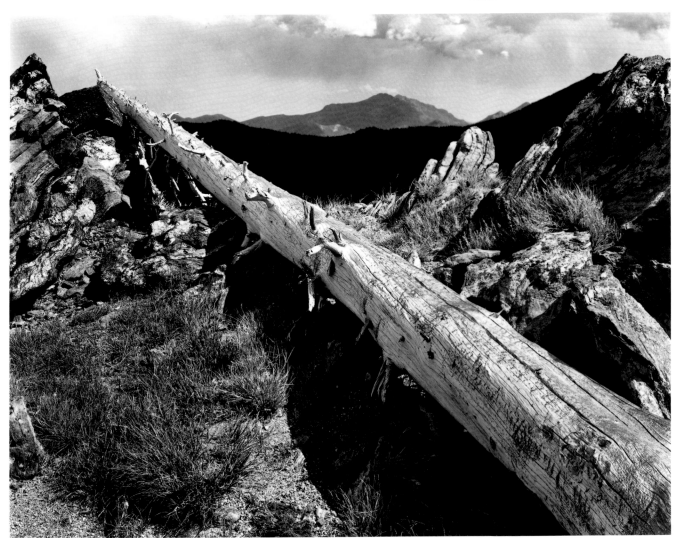

© Howard Bond

It is generally said that shorter focal length lenses or longer subject distances will increase depth of field. Conversely, longer lenses or shorter subject distances will decrease depth of field. In a sense this is true; however, it is the image size that is actually the determining factor in controlling depth of field. In fact, if two lenses of different focal lengths are used at the same aperture setting, *and the subject distance is adjusted to keep the image sizes the same*, the two lenses will produce the same depth of field.

Aperture size affects depth of field because a smaller lens opening allows fewer light rays from each subject point to reach the film, thereby producing smaller circles of confusion. As we saw earlier, reducing the size of the circles of confusion increases the sharpness of the image. The smaller the aperture, therefore, the greater the depth of field will be with a given focal length lens at any given camera-to-subject distance.

View camera adjustments affect depth of field by controlling the placement of the plane of sharp focus within the subject area. For obliquely angled or inclined subjects, you can tilt or swing the lens board so that the plane of sharp focus is angled to bring more of the desired subject area into focus. Although altering the placement of the plane of focus doesn't really change depth of field, it can use depth of field more effectively and create the illusion of a greater range of sharpness. Remember, whenever the planes of the subject, film, and lens meet on a common line (the Scheimpflug rule), it is possible to achieve a range of sharpness running from a few inches in front of the lens to infinity, even at relatively wide apertures.

Hyperfocal Distance: Another technique used to achieve maximum depth of field is to focus at the "hyperfocal distance." Stated simply, the hyperfocal distance is the nearest distance in a scene that appears sharp when the lens is focused at infinity. By refocusing the lens to this point (putting this distance opposite the focusing index mark), everything from half of the hyperfocal distance to infinity will appear sharp.

Because the hyperfocal distance changes as the lens aperture changes, it's important to know how to quickly calculate the hyperfocal distance for any given f-stop. Most small-format cameras have depth of field scales etched into the lens barrel that make figuring hyperfocal distance a simple matter of lining up the proper marks. Since most large-format lenses don't have built-in scales, you have to refer to published tables to calculate the correct distances—or use the depth-of-field dials in the KODAK *Professional Photoguide*, R-28.

You can also calculate the hyperfocal distance yourself by referring to the circle of confusion values in the table on page 35 and using the following formula. (Be sure to keep the values for lens focal length and diameters of circles of confusion in the same units—i.e. millimetres or inches.)

$$H = \frac{F^2}{f \times d}$$

where:
H = hyperfocal distance
F = focal length of lens
f = f-number setting
d = diameter of circle of confusion

Diffraction and Small Apertures:
At very small apertures, diffraction reduces image quality. Diffraction occurs when a clearly defined edge, such as an iris diaphragm of a camera lens, scatters the light passing adjacent to the edge. When the aperture is large, so much light forms the image of a subject point that the relative amount of diffracted light is negligible. But as the aperture size decreases, the total amount of light forming the image is reduced—and the diffracted light becomes a larger portion of that light. (Diffraction—caused by too small an aperture—is one of the major causes of poor image quality with pinhole cameras.)

Because print definition depends both on the sharpness of the negative and the degree of enlargement, diffraction is less serious with large-format cameras than with smaller-format cameras whose negatives must be enlarged more. Most lenses used in large-format work can be stopped down to relatively small f-stops before the effect of diffraction becomes serious; just be sure to carefully preview the image on the ground glass before making the exposure.

Lens Aberrations

For the purposes of theoretical discussion, we generally assume that a lens forms an exact image point for the light rays reflected from each subject point. In reality though, lenses form only approximations of points. Deviations from perfect image-point formation are called aberrations, and they can distort the image or affect its sharpness or color.

There are five aberrations of form: coma, astigmatism, distortion, spherical aberration and curvature of field. There are also two aberrations of color: lateral and longitudinal chromatic aberration. Any single element lens—a magnifying glass, for example, suffers from all of these to a greater or lesser degree, depending on the ratio of its lens focal length to its diameter. To improve image quality, lens designers try to find optimum combinations of different types of individual lens elements—often using one element's imperfections to cancel the reverse imperfections in another. In modern lenses, this technique has brought the correction of aberrations to a very high standard, but all lenses still have some degree of residual aberration. The effects of these aberrations are usually most pronounced at the edges of the image and when the lenses are used at their widest apertures. For critical work then, use your lenses at middle apertures and pay careful attention to the image quality at the edges of the ground glass.

Another characteristic that can adversely affect image quality is the extent of inherent flare that a lens may exhibit. Improved lens coatings have greatly reduced the flare of modern, high-quality lenses. Many lenses today have flare factors as low as 2 to 3 percent. However, the flare factors of older lenses can be fairly high—as much as 5 to 12 percent, or more—and such lenses may perform well only in high-contrast conditions where some reduction in the brightness range of the subject is not as noticeable. A properly coated lens, on the other hand, is almost a must in low-contrast conditions where any additional loss in contrast could not be tolerated.

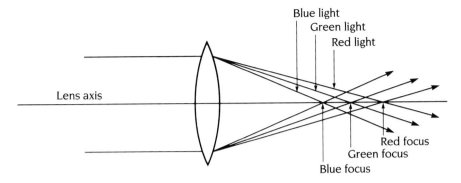

Longitudinal chromatic aberration: light of different colors is not focused in the same plane by a simple lens.

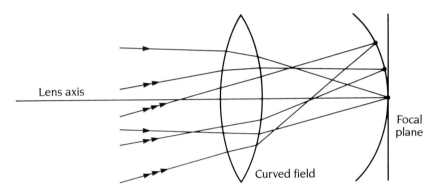

Curvature of field: light rays from subject points progressively farther from the lens axis come to focus at points progressively closer to the lens, forming a curved-field image. Sharpness decreases outward from the center of the image.

Lens flare can occur anytime, and it is most likely to affect image quality when you are working with strong backlighting or sidelighting. At best, lens flare only reduces the brightness range of the subject, but it may form streaks and hexagons (from the lens diaphragm) on the film. A properly fitted lens shade or hood is always recommended. Many photographers adjust lighting, exposure, and processing based on the flare characteristics of their lenses.

Choosing a Lens

There are many questions you have to answer for yourself before buying a lens. Will it fit the camera? Will it cover the format? What image size will it make? Does it have the required speed, and does it include a shutter? Lenses vary widely in resolving power, the degree of correction of aberrations and, of course, price. Beyond the standard selection of normal, long, and short focus lenses, there are other lens types to consider.

Wide-Field Lenses: Because one of the main advantages of using a view camera is the variety of movements and adjustments it offers, lenses with wide-field coverage can be very useful. As we mentioned earlier, wide-field lenses are designed to throw a much larger circle of illumination than an ordinary lens—and they are usually more consistently sharp across their circle of illumination. Another way to increase covering power is to intentionally use a lens designed for a larger format—using a normal lens from an 8 x 10 camera (300 mm) as a telephoto on a 4 x 5 camera, for example.

Portrait Lenses: For portrait use, the lens focal length you choose can make the difference between a natural-looking perspective and a distortion of your subject's features. Working too close with a normal or wide-angle lens, for example, enlarges the nose and makes the near side of the face look misshapen. Using a longer-than-normal focal length lens helps to flatten and

restore features to their correct proportions. A focal length of about twice normal is suggested for head-and-shoulders portraits, while a somewhat shorter lens (about one-and-a-half times normal) is good for three-quarter and full-length figures.

Soft-focus Lenses: If portraiture is your specialty, you may want to consider a soft-focus lens. While high-definition lenses that delineate every edge and shadow are fine for architectural or product work, they aren't likely to flatter your subject's ego. Many photographers prefer to use a lens specifically designed to show a

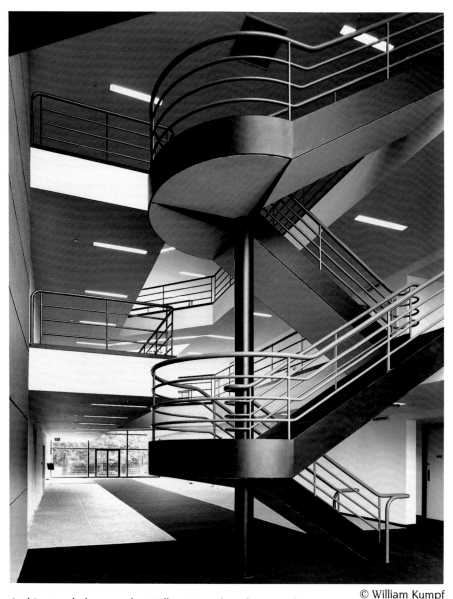

© William Kumpf

Architectural photographer William Kumpf used 4 x 5-inch KODAK TRI-X Pan Professional Film and existing light for this study in line and form.

moderate amount of spherical aberration; rather than being perfectly sharp, each image circle has a slight halo around it. The lens diffuses the image and reduces the contrast of the fine detail, softening facial wrinkles and smoothing blemishes. With many soft-focus lenses it's also possible to control the degree of softness, either by changing the aperture or by adjusting the separation between the different elements.

Convertible Lenses: Although they are not as common as they once were, convertible lenses are available as a relatively economical way to change focal lengths with a single lens. A convertible lens is made up of two parts, and either component can be used alone or in combination with the other. When combined, the two parts produce a focal length that is shorter than that of either one alone. Sharpness is best when using both and when working at smaller apertures.

Supplementary Lenses: Another inexpensive way to broaden the flexibility of your lens collection is to use supplementary lenses—individual elements that screw to the front or back of an existing lens. With supplementary lenses you can change the angle of view, increase or decrease the focal length of the prime camera lens, and alter the close-focusing distance (for more information about close-up photography, see chapter 9).

The power of a supplementary lens is expressed in diopters. A positive (+) power supplementary lens shortens the focal length of the camera lens; a negative (−) power supplementary lens increases the focal length. Using either a positive or negative supplementary lens to change the focal length of a view-camera lens always requires an exposure adjustment. When using a positive supplementary lens for close-up work, the marked aperture on the camera lens can be used without adjustment.

Working with existing-light, photographer Rob Gage shot this classic Beechcraft stag-gerwing biplane sitting on a sheet of plastic in the open desert. He used an 8 x 10 camera with a 19-inch (480 mm) lens. This photo was part of a five-week shooting assignment for an advertising campaign.

You can combine supplementary lenses for increased power. For example, a +2 and a +3 lens have a combined value of +5; a −1 lens and a −2 lens have a combined value of −3. However, keep in mind that image quality will be seriously degraded if you use more than two supplementary lenses together. Also, when combining supplementary lenses, be sure that the stronger of the two is mounted closer to the camera lens.

There are a few drawbacks involved with using supplementary lenses, not the least of which is the potential loss of image sharpness and contrast. Perhaps equally important, using posi-tive supplementary lenses to shorten the focal length of the camera lens also reduces covering power. This is seldom a problem in close-up photog-raphy, or when using lenses which have extra coverage to begin with, but it can be critical with lenses of minimal coverage or when using extreme camera movements. Be sure to examine the image corners on the ground glass carefully.

© Stephen Myers

4 Controlling the Image

Because we live in a three-dimensional world and a photograph has only two dimensions, there is a certain unreality about any photograph. A photograph has height and it has width, but it has no depth. If you're photographing a painting or a drawing, this is of no real importance since your subject has no depth. But since most subjects are three-dimensional, the portrayal of depth is a large part of their interest. To enhance the reality of a photograph you must find methods to create an illusion of the third dimension. Fortunately, a number of intriguing ways to create depth are readily available.

The reason you see the three-dimensional world with such great accuracy is because your eyes and brain view the world using a system called binocular vision. Separated by a few inches, your eyes send somewhat different images to the brain. When looking at two-dimensional objects (reading or viewing a painting, for example) the images from each eye are nearly the same and there is a "fusion" of the images in our brain—no depth is perceived. But when looking at three-dimensional objects and scenes, the images don't fuse. This creates disparity—the brain receives two slightly different viewpoints of the same scene. Assuming that the two images are logically related, the areas of disparity provide the mind with the visual information necessary to perceive depth.

But not all depth perception is related to binocular vision. To perceive three-dimensionality in a photograph, for example, the mind relies instead on monocular (one-eyed) depth cues. You can demonstrate for yourself that there are depth cues other than those based on binocular vision by closing one eye and noting that the world around you doesn't suddenly shrink into a flat two-dimensional surface. Relative size, form, texture, and lighting are some of the visual cues we use every day, both in real life and in accepting the illusions that photographs offer us. Once you become aware of them, you'll develop a heightened sensitivity to their effects.

Perspective

The most powerful depth cue is linear perspective. Linear perspective enables us to perceive distance and to judge the relative positions and sizes of objects in a scene. This illusion of depth is created by the convergence of straight lines known or thought to be parallel to one another, and by the apparently diminishing size of objects with increasing distance.

The interplay of light and shadow reveals the many textures and tones of these whitewashed farm buildings photographed by Stephen Myers. Photo made on 8 x 10-inch KODAK T-MAX 100 Professional Film.

When the camera is tilted upward so that the film plane is not vertical, vertical lines in the subject converge. Convergence can be used intentionally to emphasize the strong perspective created by the camera's viewpoint.

Linear perspective is most apparent in the lines and shapes of familiar geometric figures. If you stand at the base of tall trees or buildings and photograph them with the camera tilted upward toward the top, there is a dramatic convergence of the vertical lines of the subjects. Strong linear perspective is also evident in the convergence of parallel lines in horizontal planes. The lines in buildings, railroad tracks, or city streets narrow toward a single vanishing point (one-point perspective). Parallel lines may also converge in different planes and in different directions. When you look at the outside of a building from a corner, for example, the horizontal lines of the two sides converge toward two separate vanishing points (two-point perspective).

Linear perspective allows you to readily accept the apparent change in the size of an object as being the result of a change in distance—you know that objects look smaller when they are farther away. A car approaching from a distance grows from a small speck to its normal size, then shrinks again as it passes. This concept that an object is smaller because it is farther away is an attribute of our vision called size constancy. You know the relative sizes of real-life objects, and your mind and eye combine to process visual information for judging size and distance in a photograph. In a scene that includes a long fence winding across a field, for example, you assume that the taller posts are closer and the smaller ones are farther away. If one post looks twice as tall as another, you don't assume that it is actually two times larger. This diminishing size perspective enables you to evaluate distance with all familiar objects such as people, buildings, trees, bushes, animals, and so on. Certainly, then, the camera position you select in relation to your subjects is very important in controlling the illusion of depth in the image.

Camera-to-Subject Distance: Once the camera's position has been selected, the relative sizes of objects within the scene are locked in, regardless of what focal length lens is used. Only changing the camera's distance from the subject alters perspective. This can be illustrated by photo-

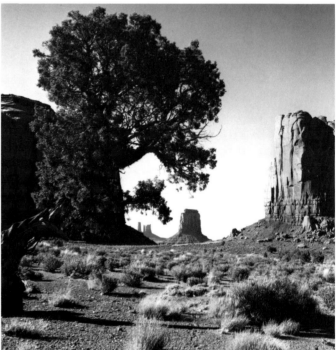

Tom Hough

Both of these scenes in Monument Valley were taken with the same lens, but there was a dramatic change in perspective when the camera was moved forward. The tree on the left became much larger, while the size of the stone monument in the center background remained virtually unchanged.

graphing a scene to include some objects in the near foreground and some at a much greater distance in the background. As the camera is moved closer to the scene, the nearest objects will increase in size faster than the more distant ones—the perspective changes noticeably.

Overlap: Another depth cue related to linear or geometric perspective is the overlap of objects within the scene. When an object in the foreground partially covers an object behind it, it's obvious that the two are at different distances, and there is no question about which object is closer. If a girl is standing in front of a stone wall, part of the wall won't be seen—or, if she stands behind the wall, part of her will be hidden. In either case, you instantly recognize the depth in the scene and know which subject is closer or farther away.

The overlap of subjects as a depth cue can be obvious or subtle. Distant mountains in a landscape or the delicate symmetry of glassware in a studio still life both reveal depth. Using overlap to accentuate depth works best when there is a series of overlaps at obviously different distances, but it is also effective even when the distances among objects is small. In choosing a camera position to emphasize depth most dramatically, however, select a viewpoint that reveals several planes of overlapping objects beginning near the camera and extending into the distance.

Focal Length: Switching to a different focal length doesn't actually change perspective, but it does alter the way we interpret the spatial relationships in a scene. Short focal length lenses tend to expand space and exaggerate perspective by making distances appear greater than they actually are. At the extreme, very short lenses distort straight lines and further enhance the sense of space in a scene.

© Thomas Guschl

These gears were photographed on 4 x 5-inch KODAK PLUS-X Pan Professional Film using a 240 mm lens. Using a moderately long lens and a relatively close working distance served to slightly compress the sense of space in this scene.

Changing focal length does not affect perspective. These three photographs were made with three different lenses and the camera remained in the same place for each exposure.

Doubling the focal length of the lens doubled the image size, and the field of view has been reduced by half, but the perspective is unchanged.

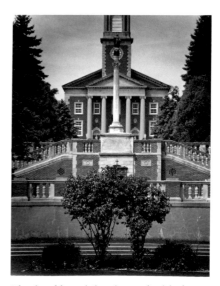

The focal length has been doubled again. If we enlarged the center of the first photo to match this image size, we would find that the perspective is the same in both images.

When this sense of spaciousness is exploited beyond a reasonable level though, it can result in false and often stunning interpretations of size and distance. Interior photographers, for example, frequently use short focal length lenses to make rooms look longer or wider than they really are—and then further disguise their sleight-of-hand by using the view camera movements to correct obvious distortions in room or furniture shape. Landscape photographers do the same thing to exaggerate the sense of spaciousness in a scenic photograph.

Very long focal length lenses have the ability to do just the opposite—they can radically compress rather than expand space and distance. Photographers often use long lenses to make distant objects look deceptively close or to make background objects seem much larger than they really are. We've all seen pictures of sailboats photographed against the setting sun through such long lenses that the boats look like they are about to sail into an imminent and fiery doom. The sun and the sailboats maintain their correct shapes, but their relative sizes and our perception of distance is altered by the long focal length.

Short- and long-focal-length lenses can also be used to create illusions by distorting the shape of objects. When the outside of a building is photographed with a very short focal length lens from a close position that shows the front and one side, the building's corner appears acutely angled and strangely pointed—looking something like the prow of a ship. But unless you are familiar with the building, you have no way to know if the photograph is lying or not. Used with small objects, ultra short lenses can so alter form that the objects become unrecognizable. Long focal length lenses, on the other hand, change form by muting or subduing the cues needed to identify three-dimensionality. Such distortions aren't as radical as those created by very wide lenses, but they can be disconcerting: horizontal lines don't converge at their normal angle and spherical objects are flattened into two-dimensional shapes.

Using a short focal lens enhanced the sense of space in this interior photograph, but the short focal length also resulted in some distortion of shapes at the edges of the image.

Changing Distance and Focal Length: Considering the powerful effects that focal length and shooting distance each have over our perception of depth, it's easy to see that by changing both at once you gain an extraordinary amount of control over a scene's perspective. For example, since short focal length lenses allow you to work much closer to your subjects, they can exaggerate perspective when used at close camera-to-subject distances. Longer lenses, on the other hand, compress apparent distance and can be used in combination with greater camera-to-subject distance to suppress or eliminate perspective.

Changing focal length and distance simultaneously can also be useful when you want to change the perspective but maintain a constant image size for a particular subject. Imagine you're using a normal lens to photograph a scene that contains prominent subjects in the foreground and in the background. If you want to strengthen the perspective but keep the fore-

ground subject at the same size, you can move closer and switch to a wider-angle lens. To subdue perspective and keep the foreground subject the same size, you could back up and switch to a longer focal length lens. Of course, the same principle can be applied to still lifes or landscapes with similar results.

Film-Plane Movements: As we discussed in chapter 2, the swing and tilt adjustments of the rear standard can be very helpful in either exaggerating or diminishing the apparent perspective. In photographing a tall building, for instance, you can radically increase the angle of convergence by tilting the film plane back away from it's vertical position. But tilt the back forward and the convergence—as well as the intensity of the perspective—begins to disappear. Similarly, perspective caused by the convergence of horizontal subject lines (horizontal building lines, for instance) can be altered by swinging the camera back to the left or right.

Changing focal length *and* distance changes perspective. This picture was made with a long-focal-length lens.

Switching to a short-focal-length lens and moving the camera forward to keep the size of the gate in the foreground the same changed the perspective considerably.

OTHER DEPTH CUES

Aerial Perspective: Aerial perspective refers to the feeling of distance created by atmospheric haze. Haze, the scattering of blue and ultraviolet radiation by moisture and airborne dust particles, makes more distant objects appear lighter in tone, less contrasty and less detailed than those nearby. The greater the distance (or the thicker the haze), the more pronounced the effect becomes. In color, aerial perspective is usually also marked by a distinct shift in subject color—distant mountain peaks may appear grayer, or take on a bluish cast; while brighter and warmer-tone subjects may become more yellowish in color. Though aerial perspective is

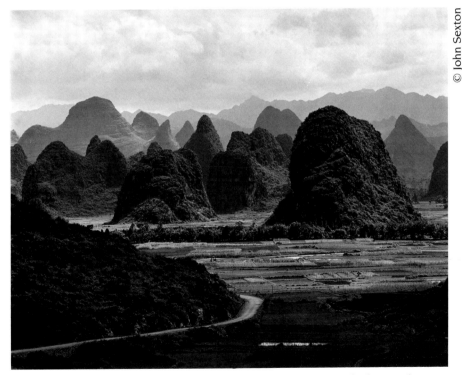

These hills near Guilin, China were photographed by John Sexton. The haze in the atmosphere affected the tones and sharpness of this scene, enhancing the sense of distance.

usually associated with distant natural landscapes, it can also be useful in enhancing the illusion of distance with hazy or smoggy city scenes.

Black-and-white films are more sensitive to blue and ultraviolet radiation than to other wavelengths. While many incorporate a UV barrier in their coatings, the effects of aerial perspective are enhanced when black-and-white films are used unfiltered. You can also heighten the effect significantly (or substantially reduce it) by using the correct filter. With black-and-white films you can intensify the appearance of haze by using a blue filter or subdue it with a yellow (no. 8), a red (no. 25), or a polarizing filter. In color, you can use a KODAK Skylight Filter No. 1A (or other ultraviolet-absorbing filter) to reduce the bluish hue of distant objects or use a polarizing filter to reduce haze. For more information on filters, see chapter 8.

Lighting and Shadows: By varying the lighting, you can heighten or suppress the appearance of depth in a photograph. Shadowing can be particularly useful in revealing the three-dimensional form of an object. As an experiment, if you light the top, front, and sides of a small white box so that they are equally bright, you'll notice that the evenness of the lighting all but eliminates the box's form. But by changing the lighting (in direction or intensity) to create a distinct difference in luminance for each of the box's surfaces, the form is restored. Similarly, to obtain the most natural form for a curved or irregularly shaped object, create a gradation of tones across the object's surface. The shapes of the lighted and shaded parts of the scene give us visual cues to the volume or form of the object. When there are a number of such objects in the scene, the total impression of depth and space is enhanced.

A change in the weather produced a dramatic change in the lighting. And the results are two radically different impressions of the same subject.

Most landscape photographers prefer to work early or late in the day when shadows are longest and the appearance of depth is greatest. Shadows cast by strong back- or side-lighting, either to the front or to the side of the subject, can dramatically heighten the perception of a scene's depth. If you've ever watched a landscape's lighting change from strong sunlight to dull diffuse light as a cloud passed by, you've seen how rapidly the feeling of distance changes. When lighting from low angles grazes across the surface of the landscape, the interplay of light and shadow makes depth more apparent. Strong sidelighting better outlines subjects against their background, increasing the sense of depth because the overlap of the subjects is more obvious. Outdoors or in the studio, revealing surface textures also depends a great deal on the direction and intensity of lighting—diffuse lighting flattens textures and obscures small details, while strong side- or backlighting emphasizes surfaces.

Depth of Field: Because a lens can focus on only one distance at a time, objects in front of and behind that distance are recorded with progressively less sharpness. But because the human eye shifts continually from one point to another while viewing a scene, reflexive focusing action makes objects at almost all distances appear to be in focus simultaneously. The only exception is when we try to look at something very close and the eye has to make an effort to readjust its focus. In part, it's this exception that causes people to interpret the combination of sharp and unsharp areas in a picture as a drastic change in distance.

If an object in the nearest foreground of a landscape is out of focus, for example, it tends to enhance the sense of distance between it and the background subjects. Interestingly though, photographs that are completely sharp from near to far are also frequently interpreted as having great depth because this is how the mind is used to viewing the world. The sense of distance is not diminished, however, if the far limit of the depth of field is just short of infinity, throwing the extreme distance slightly out of focus. Some loss of definition at extreme distances seems normal to our eyes.

Color: Though the relationship between subject color and the appearance of depth is real, colors alone are not particularly powerful depth cues. Still, the fact that we refer to red as an advancing color and blue as a receding one suggests a relationship between hue and perceived distance. Because of this, color photographs often appear more three-dimensional than black-and-white photographs of the same scene. Seen directly or reproduced in color, for example, an evenly lighted red object in front of a green background shows vivid separation. But reproduced in black and white, the same scene reveals little tonal separation—and virtually no suggestion of depth.

In choosing or establishing the depth cues for a particular image, remember that the objective of photography is not always to create a perfectly realistic rendition of the world. Photographs of some subjects are more effective when you exaggerate—or even falsify—apparent perspective, while photographs of other subjects may benefit from a weakened perspective. The basic guideline to keep in mind to help you control your images most effectively is to first select the camera position that produces the perspective or viewpoint you want. Once you've established the *relative* sizes of the subjects in the scene, select the lens that provides the desired image size and coverage.

© Nick Vedros

5 Exposure

Film Speed

Correct exposure is one of the most basic and important factors in achieving maximum photographic quality, and one of the great benefits of working with large format films is that you can expose and develop each sheet individually to match the needs of a particular situation. This is especially true of black-and-white films. With roll films, although you can vary the exposure for each frame, you develop the entire roll for the same time. But with black-and-white sheet films, you can lengthen or shorten development times—or even use different developing methods—to manipulate the tonalities and contrast for each individual sheet.

The starting point in figuring correct exposure is knowing the exact speed of the film you're using—and knowing what that means in terms of a film's response characteristics. All films are given a film speed rating (ISO number) or exposure index number that indicates directly their relative light sensitivity. Films with higher ISO numbers are more sensitive to light and therefore respond faster (called "fast" films); those with lower numbers respond slower ("slow" films). Because these numbers are arithmetic, a doubling of the number indicates a doubling of the film's sensitivity. If all other factors are equal, for example, a film with a speed of ISO 400 is twice as fast as one rated at ISO 200—it requires only half the amount of light for a correct exposure.

In general use, the published film-speed numbers for Kodak films are an excellent basis for determining the exposure needed to yield high-quality images. For more exacting applications, however, it's important to remember that these speeds are not independent of other factors in the photographic process—and are not meant to be followed blindly. Every significant element in the exposure sequence can potentially alter the effective speed of a film. Some of the factors that must be considered include:

- Inconsistencies or errors in the accuracy of light meters.
- Inconsistencies or errors in the accuracy of indicated lens openings and shutter speeds.
- Reciprocity effects for very long or very short exposure times.
- Intentional or inadvertent changes in development time or temperature.

Because there are so many variables, you should make careful film-speed tests for each of your various camera and lens combinations. Also, though all Kodak films are sensitized to exacting tolerances, effective film speeds can vary slightly with different emulsion batches and new emulsion batches should be retested for critical work. Equally important is developing a consistent set of work habits. It's not as essential that your darkroom timer be exactly accurate, for instance, as it is that it be consistent—and that you use that same timer each time you develop film.

For a complete discussion of how to obtain top-quality negatives through the proper exposure and development, see the Kodak publications listed on page 75. A highly recommended book that gives detailed procedures for determining exact film speed and exposure is Ansel Adams' classic book *The Negative*.

Exposure Meters

The fundamental tool for determining exposure is the light meter—and its purpose, of course, is to measure the intensity of light. There are basically two types of light meters: incident-light meters that measure the illumination falling onto a scene, and reflected-light meters that measure the brightness of the light reflecting from a scene. To make a reading with an incident meter you hold the meter at the subject

An incident light meter, with its white diffusing sphere, is aimed at the light source illuminating the subject. Darker subjects may require more exposure than the meter calls for—lighter subjects may require less.

Reflected light meters should be aimed at mid-tone areas of the subject, or at an 18% gray card.

This low-key image was made by photographer Nick Vedros using 4x5-inch KODAK T-MAX 100 Professional Film.

position and aim it back at the lens; with a reflected-light meter you usually stand at the camera position and aim at the subject.

Light meters are also differentiated by the angle of the light they read. Most handheld reflected light meters have an acceptance angle of between 30 to 50 degrees. The trouble with measuring such a broad angle with a standard reflected-light meter is obvious—it reads all the brightnesses reflecting from a scene, with preference to no particular area. The meter must be moved close to the subject if a small area is to be read and care must be taken to assure that the metered area isn't shadowed by your hand or the meter during the reading. Alternatively, a spot meter is a type of reflected-light meter that has the advantage of being able to make individual readings of small areas of the scene, and it can work from a distance. The acceptance angle of a typical spot meter is from 1 to 7 degrees. By comparing spot readings from the various elements in a scene, you can choose an exposure that will accurately reflect your interpretations of the subject.

With a spot meter you can calculate the exposure for a full-range scene, or measure the light from a small but important subject against a larger background that is either much lighter or darker in tone. An averaging meter would be overly influenced by the dominant background and grossly miscalculate the exposure of the smaller main subject. Since there aren't any meters built yet that have the ability to read human minds, an averaging meter has no way to know what is the important subject matter, it merely averages all brightnesses together. You could walk up to the individual elements in the scene and measure their respective brightnesses (and it's frequently done), but the nature of many scenes often makes this impossible.

Narrow-angle spot meters read only a small area of the subject. They can be especially useful for adjusting exposure with black-and-white negative films by measuring specific subject luminances.

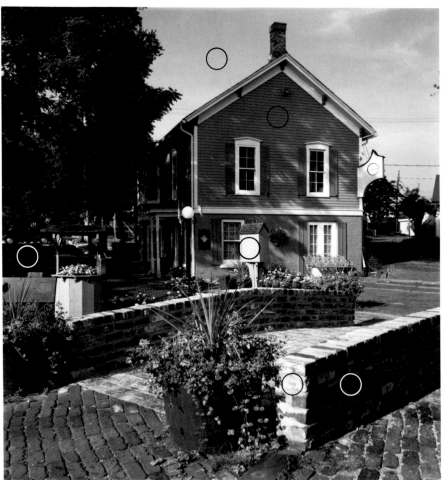

Incident meters take their readings through a diffusion sphere that usually measures a 180° arc of light falling on a subject. To take an incident light reading hold the meter at the subject position and aim it back toward the camera. While this type of metering provides a fairly accurate measurement of the illumination surrounding a particular scene, it doesn't take into account the color or reflectivity of the subject. Incident meters are particularly useful, however, in difficult or contrasty lighting situations. In trying to measure the brightness of a person's face that's strongly backlit, for instance, the meter reads only the light falling on the face and isn't affected by the extraneous spill light from behind the subject that might fool a reflected meter. Incident meters are also useful in calculating lighting ratios in studio work, in which case the meter is held at the subject position and aimed toward the light source. While an incident meter is used more often in the studio than out, when it isn't possible to get to a subject outdoors with a meter, an accurate substitute reading is possible. Simply hold the incident meter in the same light as that falling on the subject and aim the collector along the subject-to-camera axis.

A specialized-use exposure meter that is a must for studio photography is a flash meter. Most flash meters are a type of incident-light meter designed to read the actual flash illumination on the subject. Flash meters are indispensible for determining exposures and lighting ratios for multiple flash, bounce lighting, and other special-effects flash situations. Some models are even capable of calculating exposures for cumulative flash from just a single flash burst, or can read continuous and flash exposure levels simultaneously.

A film-plane meter allows you to selectively read any part of the ground-glass image. You can place the probe to measure the highlights and shadows separately.

Steve Kelly

In the studio, a flash meter is invaluable for determining exposures and lighting ratios. This photo was made on KODAK T-MAX 100 Professional Film.

Film Characteristics

In addition to having different film speeds, all films have certain unique characteristics that you must consider when figuring exposure. Contrast, tonality, color accuracy and saturation, and exposure latitude are some of the characteristics that may vary from one film type to another.

Transparency Films: Correctly exposed, color transparency films produce images of extraordinary detail in both highlights and shadows and generally offer a subtle transition of mid-tone densities. In addition, transparency films are the standard film used in making images for photo-mechanical reproduction. But exposing transparency films correctly is critical—tolerance for exposure error is usually less than one stop. In difficult situations, remember that transparency films have more of a tolerance for slight underexposure than overexposure. Transparencies overexposed by as little as one stop tend to lose color saturation and high-light detail rapidly. And contrast, the range of tonal or brightness extremes that can be imaged with good detail, is more limited than with color negative films. When contrast exceeds the range of the film, exposure will usually be a matter of compromise; sacrificing detail in one area to maintain it in another.

Negative Films: In many ways, negative films, both color and black and white, are much less demanding to deal with. Both offer far greater exposure latitude and will frequently tolerate exposure errors of up to two stops. Unlike transparency films, though, negative films have greater forgiveness on the overexposure side—underexposing negative films creates muddy shadows and lifeless gray highlights. Detail can't be created in the print if there is no density in the negative.

Negative films also have a broader contrast range, allowing you to record a full-range of tones from highlights to deep shadows. And because there is a printing step involved with negative films, a great deal of corrective manipulation can be made between the negative and the final print—a luxury that transparency films don't afford

(unless you're using them to make prints).

But again, though there is a certain amount of exposure latitude, none of these inherent tolerances are without their price. Optimum exposure for a negative film, for example, is the minimum exposure that will produce detailed shadow and highlight areas while still maintaining full separation in the midtone regions. While over-exposing may produce a similar set of tonal values, it usually results in increased negative densities which require longer printing times. Over-exposed color negatives can exhibit radical shifts in color contrast in the three emulsion layers that may not be correctable in printing. With gross overexposure (+ 2 stops or more), highlight contrast flattens out and spar-kling highlights start to disappear. Underexposure on the other hand, results in a noticeable loss of shadow detail and a similar increase in graininess.

Color Temperature: With color films, you also have to consider the color temperature of the illumination. All Kodak color films are made to be exposed to a specific color temperature, measured in degrees Kelvin (K). Daylight films, for example, are balanced for 5000 K lighting, the approximate color temperature of daylight under a clear sky. Other films are balanced for the temperatures of tungsten (3200 K) and photolamps (3400 K). Color negative films have some latitude in color temperature because corrections can be made in the printing stage. If you use a color transparency film with a light source other than the one intended, you should also use a filter at the time of exposure. For specific filter recommendations, see the film charts in the following chapter, **Choosing a Film**, or refer to the instruction sheet packed with each film. Chapter 8, **Filters**, is a general discussion of filters useful for color and black-and-white photography.

For any film, the "correct" exposure is the result of relating accurate exposure calculations to known subject and film characteristics and specific development techniques. But remember, "correct" is a relative and subjective term—in the end, the

exposures you use should be based not wholly on technical accuracy, but also on the artistic and esthetic considerations of mood, atmosphere, emotional interpretation, and individual vision.

Reciprocity

Most films, black-and-white and color, are designed to be exposed within a certain range of exposure times—usually between 1/15 second and 1/1000 second. When exposure times fall outside of this range—becoming either significantly longer or shorter—a film's characteristics may change. Loss of effective film speed, contrast changes, and (with color films) color shifts are the three common results. These changes are called reciprocity effect.

Exposure is normally calculated by multiplying the intensity of the light falling on the film by the exposure time (I x T = E). Because time of exposure (shutter speed) and intensity (aperture) share a reciprocal arrangement, as long as one is altered to compensate for changes in the other, the exposure will remain constant. But if conditions require extremely long or extremely short exposures, the reciprocity effect occurs and the film's response is altered. To compensate, exposure times, apertures and/or development times must be altered accordingly; and, with color transparency films, corrective filters must be used.

Daniel Anderson photographed the Wells Cathedral in England using a 210 mm lens on an 8 x 10 camera. The film was KODAK TRI-X Pan Professional Film 4164 (reciprocity correction required an exposure of 8 minutes at f/45).

© Daniel Anderson

Long Exposure Effects: In low-light or when depth of field requires small apertures, the longer exposure times that may be needed can result in significant film speed loss and produce thin negatives lacking shadow detail. If you increase exposure time to increase density, the density in the highlight areas becomes disproportionately greater than that in the shadows, resulting in increased contrast. There-fore, it's preferable to correct for reciprocity effect by using a larger aperture, if possible, and/or decreasing the development time.

With color films the tendency toward loss of speed caused by abnormally long exposures is more critical than with black-and-white films. You must allow not only for the overall loss of speed, but for the changes in color reproduction caused by the differ-ences in the amount of the speed change in each of the three emulsion layers. These unusual color shifts are referred to as "color cross overs." For color transparency and negative films, you can use color compensating filters on the camera; you can also correct color negative films in the printing process. In extreme cases, however, complete correction is not possible.

An exposure of 10 seconds at f/45 produced the negative from which this print was made. Notice the high contrast and lack of shadow detail.

Correcting for reciprocity called for 1 stop more exposure and 20% less development time. This reduced the contrast range and revealed more detail in the shadow areas.

If you expect low light levels or the need for small apertures, it may be simpler to use a film designed especially for longer exposures. For color negative work, KODAK VERICOLOR II Professional Film / 4108, Type L (balanced for 3200 K) has been designed to minimize reciprocity effects over an exposure range of 1/50 second to 60 seconds. Similarly, for transparencies, KODAK EKTACHROME 64T Professional Film / 6118 (3200 K balanced) can be used with exposures ranging from 2 to 10 seconds, without the use of compensating filters.

Short-Exposure Effects: Extremely short exposures, from either very fast shutter speeds (about 1/1000 second or less) or very brief electronic flash bursts, result in essentially the same effects: speed loss and/or color shifts. With color films, you can compensate for most short-exposure reciprocity effects with corrective filtration, either on the camera lens or in the darkroom. With black-and-white films, contrast is lowered and you can obtain normal contrast by increasing the recommended development time. Again, if you anticipate working with high-speed flash, consider using one of the KODAK T-MAX Professional Films for black-and-white work, or KODAK EKTAPAN Film / 4162 for color. These films have been designed to minimize short-duration effects.

Whenever correcting for reciprocity, first determine the normal exposure and then add in all the necessary adjustments for bellows extension (see chapter 9) and filtration before determining the required compensation for reciprocity. Exposure and filter compensation for the reciprocity characteristics of Kodak color films is included in the film data charts in chapter 6. For reciprocity corrections with Kodak black-and-white films, see the following section. Important film data is also provided in the instruction sheet packed with each film.

Black-and-White Correction Table:
Most Kodak black-and-white continuous-tone films respond similarly to very long and very short exposures. However, the T-MAX 100 and 400 Professional Films require a smaller exposure increase and no adjustment in development. Following the recommendations in the table will usually give adequate compensation for reciprocity effects. However, if exposure and negative contrast are critical, run tests on the film emulsion that will be used and make corrections if necessary.

The table for conventional films applies to the following KODAK Films:
EKTAPAN / 4162 (ESTAR Thick Base)
PLUS-X Pan
PLUS-X Pan Professional
PLUS-X Pan Professional / 2147 (ESTAR Base)
PLUS-X Pan Professional / 4147 (ESTAR Thick Base)
ROYAL Pan / 4141 (ESTAR Thick Base)
SUPER-XX Pan / 4142 (ESTAR Thick Base)
TRI-X Pan
TRI-X Pan Professional
TRI-X Pan Professional / 4164 (ESTAR Thick Base)

While the film latitude will generally compensate for variations in the reciprocity characteristics of different film emulsions, it is best to purchase a quantity of film of the same emulsion and run tests if you will be making a lot of long exposures. Base the tests on the table, and make corrections as necessary.

Black-and-White Films Reciprocity Correction Table*

	Exposure Time (seconds)†					
	1/100,000	1/10,000	1/1,000	1	10	100
Conventional Films (see text for list)						
Adjust Lens Aperture (f-stop) or	+1	+½	None	+1	+2	+3
Adjust Exposure Time (seconds) and	Change aperture	Change aperture	None	2	50	1200
Adjust Development	+20%	+15%	+10%†	−10%	−20%	−30%
T-MAX 100 Professional Film						
Adjust Lens Aperture (f-stop) or	—	+⅓	None	+⅓	+½	+1
Adjust Exposure Time (seconds)‡	—	Change aperture	None	Change aperture	15	200
T-MAX 400 Professional Film						
Adjust Lens Aperture (f-stop) or	—	None	None	+⅓	+½	+1½
Adjust Exposure Time (seconds)‡	—	None	None	Change aperture	15	300

*For Technical Pan Film, see the instructions packed with the film.

†KODAK EKTAPAN Film / 4162 (ESTAR Thick Base) does not require a development time adjustment for exposures of 1/1000 second.

‡No development adjustment required.

59

John Myers

6 Choosing a Film

The light-sensitive layer of a film, the emulsion, is actually a suspension of silver halide crystals in gelatin. The size, shape, and distribution of the crystals, the types of halides of which the crystals are made, their number, their sensitization during manufacture, and the thickness of the emulsion layer, along with the many controlling steps in film and emulsion manufacture, determine such film characteristics as speed, contrast, characteristic curve shape, graininess, resolving power, and optical sensitivity.

The emulsion is coated on a film base, and an overcoat of hard gelatin is placed over the emulsion to protect it from handling damage during and after processing. Most sheet films have a coating on the base side opposite the emulsion to serve as an anti-halation, antistatic, or anti-curl layer, or a combination of two or all three. In some cases the overcoat and/or the backing layer may be treated to provide a retouching surface.

Which film should you use? If you decide to work with a black-and-white film, the biggest question is how fast a film you'll need to meet existing lighting conditions and print quality requirements. Grain, tonality, and contrast characteristics go hand-in-hand with film speed, of course, so these too must be considered. Traditionally, photographers working with black-and-white films have had the choice of fine grain or high speed. However, with recent advances in film technology, films can now have fine grain *and* high speed. By reshaping silver halide crystals to provide more surface area to catch light, Kodak photographic scientists have created KODAK T-MAX Professional Films using tabular-grain technology (T-GRAIN Emulsion). The results can be viewed in two ways: films with extremely fine grain can be made

T-GRAIN Emulsion crystals Conventional silver halide crystals

When Kodak created silver halide crystals for the T-GRAIN Emulsion, crystal shape became an important factor in determining a film's characteristics, such as graininess and light sensitivity. The greater surface area of the crystals in T-GRAIN Emulsion enables them to greatly improve the graininess of films without sacrificing speed.

faster, and high-speed films can be sharper and finer grained than conventional films of comparable speed.

With color film, in addition to film speed, you have to consider color balance—matching your film to the existing light source. Though all Kodak color films can be filtered for use with virtually any light source (see chapter 8), you'll get best results when you use the film with its intended light source. In extremely difficult or contrasty lighting situations, consider exposure latitude also.

You also want to consider the final use of your images. If you're doing commercial work where the pictures will be reproduced in full-color advertisements or magazines, you'll find that reversal films are a standard requirement for publication with many printing houses. Kodak reversal films give excellent image sharpness with nearly absolute rendering of detail. And the added flexibility of push processing is an advantage that is available with Ektachrome films; you can expose them at speeds higher or

lower than normal if time adjustments are made in the first developer step. If you don't process your own film, push-pull processing service is available from Kodak and independent processing laboratories throughout the United States.

Color-negative films are used when the final results require a print. Color-print films offer broader exposure latitude than reversal films and produce negatives from which positive pictures can be made in a variety of ways. Print films can be used in photomechanical reproduction, but they're more often used for portrait or exhibition work where a top quality print is the desired end result. You can make color prints from transparencies—and transparencies from color negatives—but you'll get better results when the film is matched to the intended final product and the number of generations is kept to a minimum.

The widest variety of film types are available in sheet film. This is because large-format cameras are the first choice for many types of work including commercial and industrial photography, architectural photography, fine arts photography—any photography that requires a large film size for maximum image definition. And beyond the selection of pictorial films commonly used by professional photographers, there exists a variety of specialized sheet films for use in graphic arts, radiography, engineering, medicine, astronomy, etc. You may never come into contact with some of them, but it's good to be aware of their availability for special situations or needs.

The following film data charts describe most of the commonly used Kodak black-and-white and color films that are available in sheet-film sizes. For additional information about these or other Kodak films, see your photo dealer.

Dean Collins chose KODAK T-MAX 100 Professional Film for its smooth tonal range
and exceptional sharpness to make this nostalgic image (2X enlargement from
4x5-inch negative).

The results from medium-format T-MAX Professional Films are often comparable to those made with traditional 4 x 5 films. Using 120-size KODAK T-MAX 100 Professional Film, photographer Jock McDonald created this image as part of a calendar assignment for a fabric manufacturer (3X enlargement).

KODAK Black-and-White Sheet Films

	Description
Continuous-Tone Films	
Commercial / 4127	Blue-sensitive moderately high-contrast film for copying continuous-tone originals where red and green sensitivity is undesirable or unnecessary.
EKTAPAN / 4162	Medium-speed film suited to portraiture and close-up work with electronic flash. Also excellent for commercial, industrial, and scientific use with daylight and tungsten light.
PLUS-X Pan Professional / 4147 (PXT)	Medium-speed film with excellent highlight separation for studio use.
ROYAL Pan / 4141	High-speed film with brilliant highlight separation especially suitable for studio use and candid wedding photography with flash.
SUPER-XX Pan / 4142	Medium-speed general-purpose film with added speed for portrait, commercial, and industrial photography.
Technical Pan / 4415 (TP)	Variable-contrast film with extended red sensitivity. Low to medium to high contrast depending on development. Extremely high definition (Kodak's finest grained continuous tone film).
T-MAX 100 Professional / 4052 (TMX)	Medium-speed film yields superior results when compared to any other Kodak film of the same or comparable speed. Especially useful for detailed subjects where maximum image quality is required.
T-MAX 400 Professional / 4053 (TMY)	High-speed film with finer grain than KODAK PLUS-X Pan Film. Good for subjects in low light, stopping action, or expanding depth of field. Because of its expanded exposure latitude, you can use it at EI 800 without altering the development time. Exposure at EI 1600 and up to EI 3200 (in T-MAX Developer) can still deliver high-quality images.
TRI-X Ortho / 4163	High-speed orthochromatic film yields good shadow detail and brilliant highlights. Good for press, commercial, and industrial photography where red sensitivity is unnecessary and undesirable.
TRI-X Pan Professional / 4164 (TXT)	High-speed film yields excellent gradation and brilliant highlights. Especially suited to low-flare interior tungsten or flash lighting. Good control of contrast by development.
Special-Purpose Films	
Contrast Process Ortho / 4154	High-contrast orthochromatic film for copying black-and-white originals or black printed or handwritten matter on white, blue, green, or yellow paper.
High-Speed Infrared / 4143 (HSI)	Infrared sensitive film for aerial, industrial, legal, scientific, medical, and documentary photography, and photomicrophotography. Abstract tone reproduction for pictorial use.
Professional B/W Duplicating SO-339	Medium-contrast, direct-positive film for one-step duplication of continuous-tone black-and-white negatives or positives. Designed for making duplicates by contact printing or enlarging.
Professional Copy / 4125	Copy film with increased highlight contrast for copying continuous-tone originals. Highlight contrast mainly controlled by exposure.

| Film Speed | | Definition | | | Reciprocity | |
Daylight	Tungsten	Graininess§	Resolving Power¶	Retouching Surfaces	Charac-teristics	Color Sensitivity
50	8	VF	H 100	—	from Kodak**	Blue Sensitive
100	100	VF	H 125	Emulsion and Base	RCT††	Pan
125	125	VF	H 125	Emulsion and Base	RCT††	Pan
400	400	F	M 80	Emulsion and Base	RCT††	Pan
200	200	F	H 100	—	RCT††	Pan
EI 25*	EI 25*	MF or EF	EH 320	—	from Kodak**	Pan Extended Red
EI 100	EI 100	EF	VH 200	Emulsion and Base	RCT††	Pan
EI 400	EI 400	EF	H 125	Emulsion and Base	RCT††	Pan
320	200	F	H 100	Emulsion and Base	RCT††	Ortho
320	320	F	H 100	Emulsion and Base	RCT††	Pan
100†	50	F	VH 200	—	from Kodak**	Ortho
50‡ No. 25 Filter	125‡ No. 25 Filter	F	M 80	—	from Kodak**	Infrared
—	—	EF	VH 200	—	—	Ortho
25†	12	F	M 80	—	from Kodak**	Ortho

*Speed with KODAK TECHNIDOL Liquid Developer.
†Speed to white flame arc or pulsed-xenon arc.
‡For in-camera exposure meters that make the meter reading through a filter used over the lens, make the meter reading before putting the No. 25 filter on the lens. Use the indicated film speed in the table.

Pan—Panchromatic
Ortho—Orthochromatic

§Graininess:
MF—Micro Fine
EF—Extremely Fine
VF—Very Fine
F—Fine
M—Medium
C—Coarse

¶Resolving Power; lines per mm:
EH—Extremely High
VH—Very High
H—High
M—Medium

**Write to Eastman Kodak Company.
KODAK Information Center
Rochester, New York 14650-0811
for reciprocity characteristics

††Use Reciprocity Correction Table on page 59.

KODAK Color Sheet Films

	Description	Color Balance	ISO Speed and Filter		
			Daylight	3200 K Tungsten	3400 K Photo-lamp
Films for Color Prints					
VERICOLOR III Professional / 4106, Type S (VPS)	Medium-speed color negative film for portraits, weddings, school pictures, and other commercial purposes. For short exposure times, 1/10 second or less	Daylight	160	40 No. 80A	50 No. 80B
VERICOLOR HC Professional / 4329 (VHC)	Medium-speed color negative film with greater sharpness, finer grain, and higher contrast for commercial and industrial work. For short exposure times, 1/10 second or less.	Daylight	100	25 No. 80A	32 No. 80B
VERICOLOR II Professional / 4108, Type L (VPL)	Medium-speed color negative film for tungsten light. Somewhat higher contrast for commercial and industrial work. For longer exposure times, 1/50 to 60 seconds.	Tungsten 3200 K	64* No. 85B	100†	64‡ No. 81A
VERICOLOR ID/ Copy Film / 4078	For copy and composite work, especially where portraits and line copy are combined in a single image; exposure 1/10 to 1/10,000 second.	Daylight	100	20 No. 80A	32 No. 80B
Films for Transparencies					
EKTACHROME 64 Professional / 6117 (Daylight) (EPR)	Medium-speed film with excellent color rendition and high quality definition.	Daylight	64	16 No. 80A	20 No. 80B
EKTACHROME 100 Professional / 6122 (Daylight) (EPN)	Medium-speed film with outstanding color accuracy and good color reproduction.	Daylight	100	25 No. 80A	32 No. 80B
EKTACHROME 100 PLUS Professional / 6105 (Daylight)	Medium-speed film with increased color saturation and excellent flesh-to-neutral color balance. Also available in the KODAK READYLOAD Packet.	Daylight	100	25 No. 80A	32 No. 80B
EKTACHROME 200 Professional / 6176 (Daylight) (EPD)**	Medium-speed film with extra speed for daylight action, telephoto lenses, existing light, and extending flash distance.	Daylight	200	50 No. 80A	64 No. 80B
EKTACHROME 64T Professional / 6118 (Tungsten)	Medium-speed film designed for 3200 K tungsten lamps. For commercial studio work and copying.	3200 K Tungsten	40 No. 85B	64	50 No. 81A

| Definition | | | RECIPROCITY CHARACTERISTICS Exposure Compensation and Filter | | | | | |
| | | | Exposure Time in Seconds | | | | | |
Graininess§	Resolving Power¶	Process	1/10,000	1/1000 1/100	1/10	1	10	100
EF	H 100	C-41††	None/No Filter			NR	NR	NR
EF	H 100	C-41	None/No Filter			+1 stop CC20Y	NR	NR
EF	M 80	C-41	NR	1/50 sec None No Filter	None No Filter	None No Filter	5 sec +⅔ stop No Filter	60 sec +1⅔ stops No Filter
MF	M 80	C-41	None	None	None	None +⅓ stop	None +1 stop	NR
VF	H 125	E-6‡‡	None/No Filter			+½ stop 05R	NR	NR
VF	H 100	E-6	None/No Filter			+½ stop 05R	NR	NR
VF	H 100	E-6	None/No Filter			+½ stop 05R	NR	NR
VF	H 125	E-6	None/No Filter			+½ stop 05M	NR	NR
VF	H 125	E-6	NR	NR	See instructions with film			

*For a 1/50-second exposure
†For a 1/50-second to 1-second exposure
‡For a 1-second exposure

§Graininess:
 MF—Micro Fine
 EF—Extremely Fine
 VF—Very Fine

¶Resolving power, lines per mm:
 H—High
 M—Medium

**With KODAK EKTACHROME 200 Professional Film you can expose at two times the speed when you push-process the films by 1 stop.
††Use KODAK FLEXICOLOR Chemicals for Process C-41
‡‡Use Kodak chemicals for Process E-6
NR—Not Recommended for critical use

© Rick Alexander

7 Loading and Handling Sheet Film

Handling sheet film before and after exposure is relatively easy if you remember to treat the film gently, and to keep your equipment and work areas clean and dust-free. Rough treatment or dust and dirt will scratch and abrade film; dust and dirt will also spot it; and wet or chemically contaminated fingers will mark your negatives. As much as possible, handle the film only by the edges. The discharge of static buildup can also mark the film—particularly in dry rooms or climates; to minimize static, avoid quick sliding movements of the film and film holders.

Unless the film's data sheet offers safelight instructions, handle all sheet films in total darkness and check the film-loading and processing rooms for light leaks. Turn off the lights and stay in the room for about 10 minutes. Once your eyes are accustomed to the dark, you'll be able to see any light entering through cracks, around doors, ventilation openings, or partition joints.

If you are not accustomed to loading film holders (or developing hangers), practice these operations several times with scrap film before handling more important material. Practice first in room light and then in total darkness until you can easily load and unload film.

Before you switch off the lights to load or process film, be sure that everything you will need is in its place or within easy reach. Total darkness can be disorienting, even in a small room, and nothing is more frustrating than having to fumble around in the dark feeling for a necessary piece of equipment. If other people are in the building, make sure they know not to turn on lights or open doors in your work area. Also, it's not a good idea to unload exposed film and reload the holders in the same session—it's too easy to mix the films and accidentally expose film which has already been exposed.

Always double-check the film label to make sure you are loading the film you want, and never have two packages of different kinds of film in the loading area at the same time. If you should forget to check, you can identify specific sheet films if you're familiar with their particular notch code. All Kodak black-and-white and color sheet films have a notch pattern at one corner of each film sheet that identifies both the film type and emulsion side of the film. (When the notch is at the top edge of the upper right-hand corner, the emulsion is facing you.)

Handle the film only by the edges. Each film is identified by a specific code notch. When the notch is in the upper right-hand corner, the emulsion side of the film is up.

A surprisingly realistic architectural model photographed by Rick Alexander. The skills of the modeler and the photographer combined to bring the architect's drawings to life long before actual construction began.

Loading Sheet Film Holders

The dark slides on film holders have a tab at the pulling end that's shiny on one side and black on the other. It's standard practice in loading sheet-film holders to insert the dark slides so that the bright (usually silver or white) side of the tab faces outward when the film is unexposed. For handling in the dark, the silver side is identified by a series of easily felt notches or raised dots at the top edge of the dark slide. After exposure, reverse the slide so that the dark side is facing out. Make this practice a habit so you will avoid accidental double exposures.

Before loading, be sure that all holders are empty, then check to see that the silver tab of each dark slide faces out—so that they'll indicate they're loaded with fresh film when you're finished. Withdraw the dark slides enough to fully uncover the film opening, but don't remove the slides completely; loose dark slides are easy to misplace in the dark and they tend to attract dust if you set them down. (If you do misplace a slide in the dark, remember the notches or raised dots at the tab end will help you identify the shiny side.)

Dust your film holders each time before you use them; you can do this with a soft camel's-hair brush or, even better, an anti-static brush. Some photographers prefer small portable vacuum cleaners (designed for cleaning cameras or electronic components), because they gather rather than disperse the dust. Be particularly sure the film guides and bottom flap are free of film chips or dust. Finally, stack the holders on a bench or counter slightly to your right or left and put the film box on your other side.

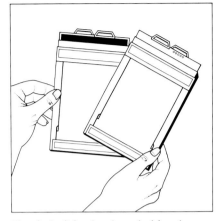

The dark slides for these holders have a white rib (with raised dots) on one side and a black rib on the other. The white side showing indicates that the holder is loaded and not yet exposed.

Before loading, open the holders and carefully dust or vacuum them.

In total darkness, remove all of the film from the package and place it emulsion side up across the open box.

With the lights out, open the outer film box and remove the inner box that's protecting the film. Inside this is a vapor-tight foil packet that's holding the film. Tear the packet open and remove all of the film from the envelope with its protective cardboard covers—pulling one sheet at a time increases the chance of scratching the film. Hold the film only by its edges and place the stack across the box. This will make it easier for you to pick up one sheet at a time. Feel for the code notches on the film and orient the stack so the film is facing emulsion side up (notch in top right corner).

While grasping the holder and holding the end flap open with the index finger of one hand, hold the film by its notched corner and slowly insert it under the two retaining guides from their open end. Make sure that the film slides under both guides, as well as the lip at the end of the holder. By sliding your index finger to the center of the outer edge, you can push the film into the holder. If the film does not seat readily, try pulling it out slightly and then guiding it into place by inserting a fingernail under the channel while pushing gently. One way to tell if the film is correctly seated is to lightly flick the notched edge of the film to see if it holds down firmly. If you feel too much slack at one side, or if one of the film's edges pulls out, gently remove the film and reload it. Be especially careful when loading not to bend or crease the film—be patient. And again, check the notch position (as shown above) to be sure the film is emulsion-side up.

Once the film is loaded on one side, push the dark slide closed (being sure it seats securely at the flap) and then lock it closed with the locking hook. Now flip the holder and load the other side.

Handling the film only by the edges or corners, hold back the film holder flap and guide the film under both channels.

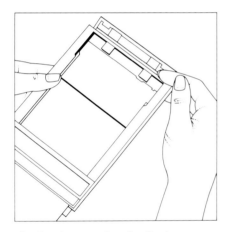

Check to be sure that the film is completely inserted. "Short loading" will make the dark slide difficult to insert and cause problems when using the holder in the camera.

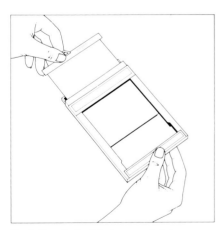

Push the dark slide in completely. When both sides are loaded, lock the slides to prevent them from being removed accidentally.

Developing Black-and-White Sheet Films

You can develop sheet film in a tank or in a tray. In tank developing, you load the sheets into hanging frames and agitate them by lifting the hangers up and out of the developer. To develop several films in trays, agitate by continually interleaving the sheets. Tray development is simpler and less expensive, particularly if you are processing only a few films at a time. Tanks are more convenient for larger quantities of film. Whichever method you select, pay close attention to solution temperatures and proper agitation to assure uniform development, and always handle the films carefully to avoid scratches.

Tray Development: Tray development of black-and-white sheet films is easy to master, and when you only have a few sheets to develop, requires a lot less developer than a tank (which has to be full whether you're developing one sheet or a dozen). Use a tray size that provides enough room for your hands to manipulate the films. 8 x 10-inch trays are adequate for 4 x 5-inch films, for example, but 11 x 14-inch trays offer more freedom of movement. The developer must be deep enough to cover the number of films you're working with—usually an inch or so is plenty (provided you have sufficient developer capacity for the number of sheets you're working with).

If you are processing only one or two sheets, individually slide each film into the developer tray emulsion side up; rock the tray immediately to make sure that the films are completely covered by developer and not sticking together. To agitate the film, first raise one side of the tray 3/4 inch, then lower it smoothly and immediately raise and lower the other side (the agitation cycle should take about eight seconds). Continue these movements throughout the developing time until it is complete.

You can also use interleaving continuous agitation when you are processing several films in a tray. Before you begin processing, prepare a tray of clean water at the same temperature as the developer. Presoaking films in a water bath for 30 seconds helps to prevent the films from sticking to one another and assures even development.

Holding the film at one corner, quickly slide each sheet into the tray. Be sure the film is completely immersed, emulsion side up.

With only one or two films, agitate by gently rocking the tray.

When you are ready to start, unload the film holders (or an "exposed" film box) and fan the films out in your hand so that the code notches are all facing in the same direction (top right). Place the films in the water one at a time, emulsion side up, in a stack with the first film on the bottom. As you place each film in the tray, make sure it is completely covered with water before inserting the next one. Once all the films are in the water, start with the sheet at the bottom and leaf through the pile twice. Be careful that the corners of the sheet you are handling do not scratch the sheet below it—use a smooth sliding motion to immerse the films.

Because it is important that you go through the stack of films completely, you can keep track of where you are in the pile by rotating each sheet 90 degrees as you bring it to the top. Another helpful trick is to rotate the first film into the developer by 180 degrees from the others, so you'll know which film you began with (its notches will be at the opposite end) and you can make sure that it's the first film out.

Remove the first film from the water bath, allow it to drain, and transfer the film to the developer. Repeat the process until all of the films are in the developer. To agitate the films, continuously interleave them from the bottom to the top of the stack until development is complete. Count the films before you begin and again as you agitate them to be certain that two films aren't sticking to each other.

When the first film has reached the correct developing time, begin transferring the films to the stop bath in the same manner—being sure that you maintain the order of the films through each succeeding step. To avoid contamination of the developer by the stop bath, use one hand for lifting the films from the developer and the other hand for placing them in the stop bath. Continue with the remaining procedures in a similar manner, following the specific processing instructions provided for each type of film.

When processing several films, fan them out in your hand, emulsion side up, to make them easier to handle.

After all of the films have been immersed in the developer, agitate by continuously interleaving the stack, going from bottom to top.

After washing, air dry the films by hanging each one from a film clip (or plastic clothes pin) in a dust-free location or film drying cabinet. Make sure that none of the films are touching one another. To minimize water spotting, bathe the film in diluted KODAK PHOTO-FLO Solution for 30 seconds, and drain before drying. Follow the directions carefully; the correct dilution of the PHOTO-FLO Solution is important.

Tank Development: If you're developing sheet films using the tank method, reserve a clean dry area for loading the film hangers. In room light, open the hinged tops of all the hangers and place them within easy reach—an extra tank (also clean and dry) works well as a holding tank. Keep another tank or a rack nearby to store the loaded frames.

To load a hanger, hold the hanger in one hand and slide the film gently into the side channels with the other hand. All emulsion surfaces should be facing forward, and no two film hangers should have the emulsion sides facing one another. You may have to tap the edge of the frame lightly (or the back of the film) if the film hangs up, but be patient and treat the film gently. Feel the top edge to see that the film is all the way in before you close the hinged top or you'll bend the film. Once loaded, carefully bring all the frames to the wet area and, with the timer set, begin the development process.

The frames should be immersed gently and all at the same time. To dislodge air bells, tap the hangers sharply on the top of the tank two or three times. Allow the hangers to remain undisturbed for the remainder of the first minute.

Insert the film in the hanger, emulsion side facing forward. Be sure the film is all the way in before closing the hinged top.

Dry each film by hanging from a film clip or plastic clothes pin at one corner.

Holding a stack of loaded hangers with the emulsion side of each film facing you, lower them as a unit into the developer.

To agitate the films, gently lift the batch of frames entirely out of the solution and tilt them almost 90 degrees to one side. Allow the films to drain for a few seconds, then re-immerse and lift again, tilting them in the opposite direction. Be sure that the films are separated and replace them in the solution. Repeat this agitation cycle every minute during the development time, taking about six seconds for each cycle. Do not dry the films in their hangers.

For a more complete discussion of development times and agitation patterns, plus the remaining processing procedures, see the instructions packaged with your film.

Storing Film

Unexposed and unprocessed films are perishable and their characteristics will change slowly with time. Care can be taken, however, to prevent rapid changes brought about by high temperature and high relative humidity, or changes caused by the chemical activity of materials that aren't photographically inert. Except in extreme conditions (long-term storage in tropical environments) it is unnecessary to control the humidity when storing Kodak films if they remain in the original vapor-tight packaging. Generally, however, the relative humidity should not go above 70-percent.

The storage temperature for unexposed and unprocessed films must be controlled—even if the storage is short-term. Most unexposed Kodak black-and-white and color films for general use can be stored in normal room conditions, if the temperature does not exceed 75°F (24° C) before the films are used. Above that temperature, color films may begin to show noticeable color shifts and black-and-white films may show a loss of film speed and contrast.

If necessary, you can store black-and-white films for several years in a freezer at a temperature of 0°F (−18°C). Low-temperature storage has no permanent effect on the photographic characteristics of the film,

Lift the hangers out of the tray and tilt them. Be careful not to dislodge the films by lifting the hangers too quickly.

although background radiation will eventually affect the film; normal deterioration is merely retarded. Of course, enough warm-up time (usually at least an hour) must be allowed before opening the factory-sealed package to prevent condensation damage.

Kodak professional color films are designed for optimum performance close to the time of manufacture and packaging, and they should always be stored under refrigeration until the day of use. The films will retain optimum color balance and contrast when they are stored at 55° F (13° C) or lower, until the expiration date printed on the film carton. Cold storage is recommended for these films because it helps maintain their original characteristics and quality for critical professional photographic applications.

All photographic films should be processed immediately after exposure to prevent changes in the latent image. This is especially important for Kodak professional color films, though there is a small amount of tolerance for delay. Film exposed within a week of being removed from refrigeration and processed within the next week, for instance, will usually produce satisfactory results. It is enough to exercise reasonable care and judgment. More extensive information about obtaining the longest life possible from negatives, slides and paper prints can be found in KODAK Publication F-40, *Conservation of Photographs.*

Code Notches For KODAK Sheet Films

	Code Notch		Code Notch
KODAK Black-and-White Films			
EKTAPAN / 4162 (ESTAR Thick Base)		T-MAX 100 Professional / 4052	
High Speed Infrared / 4143 (ESTAR Thick Base)		T-MAX 400 Professional / 4053	
PLUS-X Pan Professional / 4147 (ESTAR Thick Base)		TRI-X Ortho / 4163 (ESTAR Thick Base)	
ROYAL Pan / 4141 (ESTAR Thick Base)		TRI-X Pan Professional / 4164 (ESTAR Thick Base)	
SUPER-XX Pan / 4142 (ESTAR Thick Base)			

Universal Code Notches	
For Black-and-White Processes	
For Process C-41	
For Process E-6	

Note: These universal code notches are for low-volume and special-order (SO) products.

	Code Notch		Code Notch
KODAK Color Negative Films			
VERICOLOR III Professional / 4106, Type S		VERICOLOR HC Professional / 4329	
VERICOLOR II Professional / 4108, Type L		VERICOLOR ID/Copy Film / 4078	

	Code Notch		Code Notch
KODAK Color Reversal Films			
EKTACHROME 64 Professional / 6117 (Daylight)		EKTACHROME 200 Professional / 6176 (Daylight)	
EKTACHROME 100 Professional / 6122 (Daylight)		EKTACHROME 64T Professional / 6118 (Tungsten)	
EKTACHROME 100 PLUS Professional / 6105			

For More Information

Kodak offers the following publications that are available from dealers who sell Kodak products, or you can order them directly from Kodak through the order form in KODAK Publication No. L-1, KODAK Index to Photographic Information. To obtain a copy of the current index, send your request with $1 to Eastman Kodak Company, Department 412-L, Rochester, New York 14650-0532.

B-3 Handbook of KODAK Photographic Filters

E-26 KODAK VERICOLOR III Professional Film

E-30 Storage and Care of KODAK Films and Papers—Before and After Processing

E-37 KODAK EKTACHROME Professional Films (Process E-6)

E-38 KODAK EKTACHROME Duplicating Films (Process E-6)

E-77 KODAK Color Films and Papers for Professionals

F-5 KODAK Professional Black-and-White Films

F-32 KODAK T-MAX Professional Films

M-1 Copying and Duplicating in Black-and-White and Color

O-22 Photo Decor

R-19 KODAK Color Darkroom DATAGUIDE

R-20 KODAK Black-and-White Darkroom DATAGUIDE

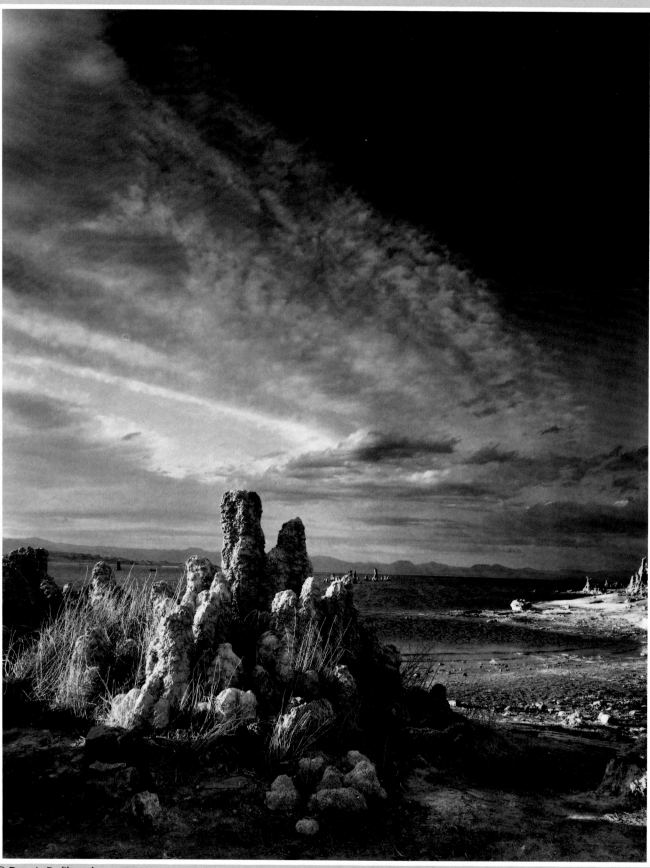

© Dennis Defibaugh

8 Filters

After a sharp lens, a good exposure meter, and a sturdy tripod, a wide selection of filters is one of the best investments you can make in photographic accessories. In spite of the simplicity of their appearance, filters perform surprising feats. You can use them to alter color balance, manipulate tonalities and contrast, control light intensity, remove unwanted reflections, and even reduce atmospheric haze. And creatively, filters can lead you down paths of imagination and fancy that you may have never realized existed.

Photographic filters are basically made in two styles: round optical-glass disks in threaded metal or plastic mounts and unmounted squares of glass, plastic or gelatin. Most small-format photographers use the mounted glass disks that thread directly to the lens. Screw-on filters are popular because they're durable and convenient. In large-format photography, though, many photographers commonly rely on flexible (and fragile) gelatin squares. These filters are usually mounted into hard frames or holders and then attached to the lens by a filter holder or hood.

Gelatin filters, such as KODAK WRATTEN and Color Compensating Filters, offer several advantages for large format photographers. Manufactured in a broad range of colors and densities, they provide considerable control and flexibility when working with existing light. In addition, Kodak gelatin filters are considerably less expensive than comparable glass filters, offer exceptional optical clarity, and come in a wide variety of sizes, including 50 mm, 75 mm and 100 mm. Gelatin filters are also lighter and take up less space, allowing you to conveniently carry a wider variety into the field.

Dennis Defibaugh photographed the stark beauty of Mono Lake located below the eastern range of the Sierra Nevada mountains.

A compendium lenshood/filter holder. The flexible bellows allows you to adjust the hood for the best effect.

How Filters Work

All filters, whether for color or black-and-white photography, work by absorbing certain wavelengths (colors) of light. Because films are made to respond to specific colors of light, altering the light as it enters the lens changes the results the film produces. In certain situations, filtration can help compensate for some characteristics in the response of the film. For example, a black-and-white film that is overly sensitive to the blue and invisible ultraviolet radiation reflected in the sky will tend to overexpose the sky area if used unfiltered. By placing a filter over the lens that absorbs that excess blue and ultraviolet radiation, you can record the sky with the same relative color that our eyes perceive and expect.

Many color films, and some black-and-white films, such as KODAK T-MAX Films, have UV barriers incorporated into them. This makes the films less sensitive to blue light and UV radiation without any other camera filtration.

Knowing what colors of light a particular filter absorbs, and visualizing the effect that filter will have on a particular film, are critical to the effective use of filters. The single most important rule to remember in understanding how filters work is this: Colored filters pass light of their own color and absorb other colors, either partially or completely. In black-and-white photography, color filters change print tones; in color, they tint the overall scene.

Filter Factors: Because a filter works by absorbing light of some colors, less light reaches the film. This usually makes it necessary to either increase the exposure time or use a larger aperture to compensate for the absorbed light. The amount of correction needed is called the filter factor. The corrected exposure is figured either by multiplying this factor by the shutter speed or by converting the factor to stops and adjusting the aperture.

Filters for Color Films

As a rule, corrective filtration is not necessary when you expose a color film to its intended light source. But as with all rules, there are exceptions. Correction filters may be necessary, for example, when the color quality of artificial lighting does not match the color balance of the film, or when the time of day causes daylight to take on unwanted color shifts. Filters can also save the day when you find yourself unexpectedly shooting with the wrong film/lighting combination. Correction filters for color photography are divided into three groups: color compensating (CC), light balancing, and conversion filters. Though you'll rarely need to stock a full complement of each, knowing what's available can help you find a solution for almost any difficult situation.

Color Compensating Filters: As their name implies, color compensating ("CC") filters can adjust the overall color balance of a photograph or compensate for inadequacies in the color of the existing lighting. These filters don't alter the entire spectrum of light in a scene—they act principally on one color. The approximate visual density of each color compensating filter in the following table is indicated by the numbers in the filter designation, and the color is indicated by the final letter. In a typical filter designation, CC20Y, "CC" stands for "color

Conversion of Filter Factors to Increase in Exposure in Stops

Filter Factor	+ Stops	Filter Factor	+ Stops	Filter Factor	+ Stops
1.25	+ ½	4	+ 2	12	+ 3⅔
1.5	+ ⅔	5	+ 2⅓	40	+ 5⅓
2	+ 1	6	+ 2⅔	100	+ 6⅔
2.5	+ 1⅓	8	+ 3	1000	+ 10
3	+ 1⅔	10	+ 3⅓		

compensating," "20" for a density of 0.20 and "Y" for "yellow."

KODAK Color Compensating Filters are available in the three primary (red, green, blue) and three secondary (yellow, cyan, magenta) colors. The standardized density spacing of the filter series ranges from .025 to .50, and this helps to predict the photographic effects of filter combinations. You can use CC filters in combinations of two or three filters without a notable loss in sharpness, but only the minimum number necessary to produce the desired correction should be used. For example, a 10R can be substituted for a 10Y + 10M, a 30G for a 30Y + 30C, or a 20B for a 20M + 20C.

The densities of CC filters are measured at the wavelengths of maximum absorption. That's the reason the term *peak density* is used in the table. Thus, for example, the density of a yellow filter is given for blue light.

Color compensating filters are useful when working with unusual lighting sources. Fluorescent lights, for instance, are abundant in green and blue light but lacking in red—causing pictures on daylight color film to appear greenish. By adding a magenta compensating filter (usually CC30M), excess green is absorbed and a normal color balance is restored. For additional filtration guidelines when exposing color films with fluorescent lamps, refer to the chart on page 81.

Photographers also often use color compensating filters to correct for minor variations in color balance caused by normal manufacturing variations in film emulsions or by abnormalities in exposure times or processing. In addition, CC filters can be used to subtly punch up a subject of the same color in a scene—using a 20Y to enhance the yellow of bananas in a still life, for example.

Light Balancing Filters: Light balancing filters are placed over the camera lens to make *minor* changes in the color quality of the light reaching the film. They are used to obtain a slightly cooler (bluer) or warmer (yellower) color rendering. The two series of KODAK Light Balancing Filters are the No. 82 (bluish), and the No. 81 (yellowish), and both series are available in a variety of densities.

Using filters in the 82 series is equivalent to raising the color temperature of the light, giving pictures a colder appearance. The 82 series filters are frequently used to counteract the excessive yellow light of very early and late daylight, or of tungsten lighting. The 81 series filters effectively lower the color temperature of existing light, creating warmer renditions of outdoor scenes. You can use 81 series filters to create a false warmth on heavily overcast days, or to reduce the excessive bluishness of open shade or high altitude lighting.

When you have a color-temperature meter to determine the color temperature of the prevailing light, or when the color temperature is already known, use the table on page 80 to convert the prevailing temperature to either 3200 K or 3400 K.

Conversion Filters: Conversion filters produce *significant* changes in the color temperature of the illumination (e.g. daylight to artificial light). This makes them useful in obtaining correct results when the color balance of the film does match the color temperature of the light source. As we mentioned earlier, all Kodak color films are designed to be used with light of a specific color temperature. Exposing a film to a different temperature of light will create an overall color cast—which in some cases can be used to creative advantage, but is usually offensive. Using a daylight- (5000 K) balanced film with tungsten (3200 K) lighting, for example, produces images with a distinct orange cast because tungsten sources radiate far more red light. Conversely, using a tungsten-balanced film in daylight produces bluish images.

Conversion filters from Kodak are available as KODAK WRATTEN Gelatin Filters. They come in two series: a No. 85 (yellowish) series for using tungsten films in daylight and a No. 80 (bluish) series for using daylight films with tungsten lighting. These filters are also available in several densities to compensate for slight variances from one type of lighting to another. Consult the accompanying table for specific recommendations. The filters can be placed between the light source and the other elements of the system, or over the camera lens.

Reciprocity and Color Filters: At exposure times longer or shorter than the nominal time for which a film is designed, the filter and film combination may not produce the results expected. At short or long exposure times, color films may require an adjustment with CC filters. For additional information on reciprocity effects, see page 56, or refer to the film data charts in chapter 6.

KODAK Color Compensating Filters

Nominal Peak Density	Yellow (Absorbs Blue)	Exposure Increase in Stops*	Magenta (Absorbs Green)	Exposure Increase in Stops*	Cyan† (Absorbs Red)	Exposure Increase in Stops*
0.025	CC025Y	—	CC025M	—	CC025C	—
0.05	CC05Y‡	—	CC05M‡	1/3	CC05C‡	1/3
0.10	CC10Y‡	1/3	CC10M‡	1/3	CC10C‡	1/3
0.20	CC20Y‡	1/3	CC20M‡	1/3	CC20C	1/3
0.30	CC30Y	1/3	CC30M	2/3	CC30C	2/3
0.40	CC40Y‡	1/3	CC40M‡	2/3	CC40C‡	2/3
0.50	CC50Y	2/3	CC50M	2/3	CC50C	1

Nominal Peak Density	Red (Absorbs Blue and Green)	Exposure Increase in Stops*	Green (Absorbs Blue and Red)	Exposure Increase in Stops*	Blue (Absorbs Red and Green)	Exposure Increase in Stops*
0.025	CC025R	—	CC025G	—	CC025B	—
0.05	CC05R‡	1/3	CC05G	1/3	CC05B	1/3
0.10	CC10R‡	1/3	CC10G	1/3	CC10B	1/3
0.20	CC20R‡	1/3	CC20G‡	1/3	CC20B	2/3
0.30	CC30R	2/3	CC30G	2/3	CC30B	2/3
0.40	CC40R‡	2/3	CC40G	2/3	CC40B	1
0.50	CC50R	1	CC50G	1	CC50B	1 1/3

*These values are approximate. For critical work, they should be checked by practical test, especially if more than one filter is used.

†Another series of cyan color-compensating filters with more absorption in the far-red and infrared portions of the spectrum is available in the listed densities. These filters are designed with the suffix "2" (i.e., CC025C-2) and should be used in preference to other cyan filters when required in filter packs for printing KODAK EKTACOLOR Papers. Similar KODAK Color Printing Filters (Acetate) are available in .025, .05, .010, .20, and .40 cyan densities.

‡Similar KODAK Color Printing Filters (Acetate) are available for making color prints.

KODAK Light Balancing Filters

Filter Color	Filter Number	Exposure Increase in Stops*	To obtain 3200 K from:	To obtain 3400 K from:
Bluish	82C + 82C	1⅓	2490 K	2610 K
	82C + 82B	1⅓	2570 K	2700 K
	82C + 82A	1	2650 K	2780 K
	82C + 82	⅔	2720 K	2870 K
	82C	⅔	2800 K	2950 K
	82B	⅔	2900 K	3060 K
	82A	⅓	3000 K	3180 K
	82	⅓	3100 K	3290 K
No Filter Necessary			**3200 K**	**3400 K**
Yellowish	81	⅓	3300 K	3510 K
	81A	⅓	3400 K	3630 K
	81B	⅓	3500 K	3740 K
	81C	⅓	3600 K	3850 K
	81D	⅔	3700 K	3970 K
	81EF	⅔	3850 K	4140 K

*These values are approximate. For critical work, they should be checked by practical test, especially if more than one filter is used.

KODAK Conversion Filters

To Convert	Use KODAK Filter No.	Filter Color	Exposure Increase in Stops*
3200 K to Daylight (5500 K)	80A	Blue	2
3400 K to Daylight (5500 K)	80B	Blue	1⅔
3800 K† to Daylight (5500 K)	80C	Blue	1
4200 K‡ to Daylight (5500 K)	80D	Blue	⅓
Daylight (5500 K) to 3800 K	85C	Amber	⅓
Daylight (5500 K) to 3400 K	85	Amber	⅔
Daylight (5500 K) to 3200 K	85B	Amber	⅔

*For critical work, check these values by practical test.
†Aluminum-filled clear flashbulbs, such as M2, 5 and 25.
‡Zirconium-filled clear flashbulbs, such as AG-1 and M3.

Filters for Color Photography Under Fluorescent Lighting

**Guides for Initial Tests when Exposing Color Films
with Fluorescent and High-Intensity Discharge Lamps**

NOTE: Red or blue filters have been included to limit the number of filters to three.

Type of Lamp	KODAK Color Film			
	VERICOLOR III Professional; VERICOLOR HC Professional; EKTAPRESS GOLD Professional; EKTAR Professional	EKTACHROME 100 PLUS Professional, EKTACHROME 64 Professional	KODACHROME 64 Professional	VERICOLOR II Professional; EKTACHROME 160 Professional, EKTACHROME 64T Professional
Fluorescent				
Daylight	40R +⅔ stop	50R +1 stop	45R + 10M +1⅓ stops	No. 85B + 40M +30Y + 1⅔ stops
White	20C + 30M +1 stop	40M +⅔ stop	05C + 40M +1 stop	50R + 10M +1⅓ stops
Warm White	40B +1 stop	20C + 40M +1 stop	25B + 20M +1⅓ stops	50M + 40Y +1 stop
Warm White Deluxe	30B + 30C +1⅓ stops	30B + 30C +1⅓ stops	40B + 05C +1⅓ stops	10R +⅓ stop
Cool White	30M +⅔ stop	40M + 10Y +1 stop	15R + 30M +1⅓ stops	60R +1⅓ stops
Cool White Deluxe	20C + 10M +⅔ stop	20C + 10M +⅔ stop	05B + 10M +⅔ stop	20M + 40Y +⅔ stop
Unknown Fluorescent*	10C + 20M +⅔ stop	30M +⅔ stop	05C + 30M +1 stop	50R +1 stop
High-Intensity Discharge				
General Electric Lucalox†	70B + 50C +3 stops	80B + 20C +2⅓ stops	70B + 30C +2⅔ stops	50M + 20C +1 stop
General Electric Multi-Vapor	10R + 20M +⅔ stop	20R + 20M +⅔ stop	30R + 15M +1⅓ stops	60R + 20Y +1⅔ stops
Deluxe White Mercury	20R + 20M +⅔ stop	30R + 30M +1⅓ stops	30R + 30M +1⅓ stops	70R + 10Y +1⅔ stops
Clear Mercury	80R +1⅔ stops	70R‡ +1⅓ stops	120R + 20M§ +3 stops	90R + 40Y +2 stops

NOTE: Except for the KODAK WRATTEN Filters No. 85 and 85B, all filters are KODAK Color Compensating Filters (CC). Increase exposure by the adjustment given. Do not use sodium-vapor lamps for critical applications. Red filters have been substituted for equivalent values in magenta and yellow, and blue filters have been substituted for equivalent values in cyan and magenta. These substitutions were made to reduce the number of filters or to keep the exposure adjustment to a minimum (or both).

*When you don't know the type of fluorescent lamps, try the filter and exposure adjustment given; color rendition will be less than optimum.

†This is a high-pressure sodium-vapor lamp. The information in the table may not apply to other manufacturers' high-pressure sodium-vapor lamps because of differences in spectral characteristics.

‡For EKTACHROME 400 Film (Daylight) and EKTACHROME P800/1600 Professional Film, use 25M +40Y and increase exposure by 1 stop.

§This combination includes 4 filters; it is an exception to our recommendation of using a maximum of 3 filters.

Filters for Black-and-White Films

The main reason for using filters in making black-and-white images is because black-and-white films don't record the world exactly the way our eyes see it. Although most black-and-white films are sensitive to all colors of light in a scene, they are more sensitive to some of those colors than to others. Objects of different colors we see may appear almost identical in tone in a black-and-white print. By using filters, you can re-establish the tonal relationships as you saw them—or exaggerate them to create your own creative interpretations. Considering that our eyes can detect some 200 separate shades of gray, the use of filters in black and white becomes important indeed.

Basically there are two types of filters used in black-and-white photography: correction filters and contrast filters. Correction filters are necessary to record the brightness relationships within a scene with the same relative intensity that our eyes and brain remember them. In an unfiltered photograph of a landscape, for instance, blue skies (to which some black-and-white films are overly sensitive) are recorded lighter than we remember them, and green foliage (to which the films are relatively insensitive) is darker. By using a No. 8 yellow filter, however, the foliage lightens and the sky darkens to a more natural gray tone. The filter absorbs excess blue, while allowing the green of foliage to pass to the film.

Many times, however, simply recapturing the actual brightnesses of a scene isn't enough to create a realistic interpretation. Black-and-white films often reproduce different colors as similar tones although our eyes may see them as entirely different levels of brightness. For example, although our eyes would see a distinct difference between red and green paint, in the picture below shot with no filter, the red and green paint blobs are very similar shades of gray. However, the contrast changes dramatically with a No. 25 deep red filter that lightens the red paint and darkens the green. Similarly dramatic changes occur with the No. 58 green and No. 47 blue filters.

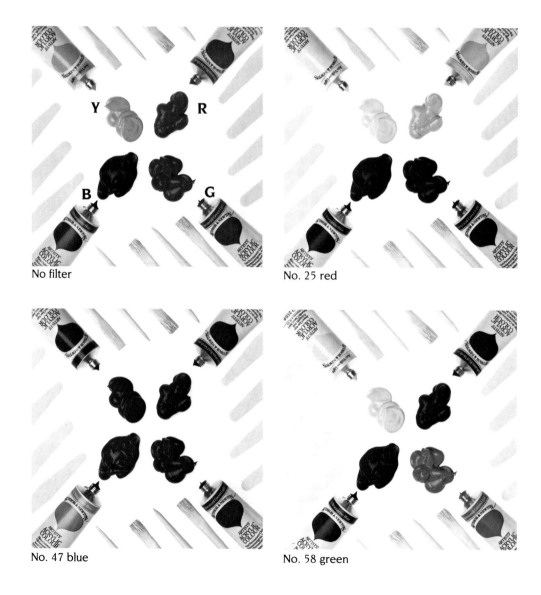

No filter

No. 25 red

No. 47 blue

No. 58 green

The simplest way to predict what effect a filter will have is just to remember that a filter lightens objects of its own color and darkens objects of complementary colors. To lighten a blue flower or blue sky, use a blue filter. To darken blue subjects, use a yellow filter. The accompanying filter chart will help you select specific filters to lighten or to darken the gray-tone rendering of most colors. For example, the No. 58 green filter will freely transmit light from objects that are green, yellow and blue-green (lightening them in the final print) and block magenta, orange and red (darkening them). The approximate filter factors for use in daylight and tungsten light are also given in the table. These factors are often different because tungsten light contains relatively more red light, and daylight contains relatively more blue light.

Depending on the type of film and meter you are using, you may be able to take meter readings for exposure adjustments through the filter or at the ground glass. However, not all meters are completely accurate with all colors and this can be critical in black-and-white work. For example, meter readings may not be reliable with the so-called sharp-cutting black-and-white

filters (58, 61, 47, 49, 29, 25, etc). The meter doesn't compensate for the type of black-and-white film being used, and different panchromatic films have different filter factors. This is why it's a good idea to compare your readings against the filter factors listed in the table.

Haze Reducing Filters

Although atmospheric haze can be a desirable cue to depth and distance in landscapes, too much haze can obscure distant objects and details in a photograph. Again, when using a black-and-white film that is overly sensitive to the excess blue and invisible ultraviolet radiation scattered by haze, prints of distant scenes often appear veiled by a grayish smog. With panchromatic films, yellow, deep-yellow, and red filters will reduce the appearance of haze because they absorb excess blue and ultraviolet wavelengths. The degree of haze reduction will depend on the density of the filter (filters in a given color become more dense as the filter number gets higher). You can also use polarizing filters to reduce haze in black-and-white and color photographs.

KODAK High Speed Infrared Film is especially good for penetrating haze when used with a No. 25 red, No. 29 deep-red, or No. 87 filter. This film is sensitive to invisible infrared radiation which is able to penetrate even thick haze. Infrared films require special handling and processing; to read more about them refer to KODAK Publication No. M-28, *Applied Infrared Photography*. Remember, however, fog and mist may look like haze, but they are composed of water droplets and cannot be removed by any combination of film and filters.

Skylight filters for use with color films have little or no effect in removing haze in either color or black and white. Their primary use is to slightly reduce the excess blue light found in shade or on overcast days and in images of distant scenes at high elevations. Skylight filters also absorb ultraviolet radiation.

Corrections for KODAK PLUS-X Pan, T-MAX,* and TRI-X Pan Professional Black-and-White Films

Filter number	Color of filter	Daylight		Tungsten	
		Increase the exposure time by this factor Or	Open the lens by (f-stops)	Increase the exposure time by this factor Or	Open the lens by (f-stops)
8	Yellow	2 (1.5)	1 (⅔)	1.5 (1.2)	⅔ (⅓)
11	Yellowish-Green	4 (3)	2 (1⅔)	4 (3)	2 (1⅔)
15	Deep Yellow	2.5 (2)	1⅓ (1)	1.5 (1.5)	⅔ (⅔)
25	Red	8 (8)†	3 (3)	5 (4)	2⅓ (2)
47	Blue	6 (8)	2⅔ (3)	12 (25)	3⅔ (4⅔)
58	Green	6 (6)	2⅔ (2⅔)	6 (6)	2⅔ (2⅔)
Polarizing Filter	Gray	2.5 (2.5)	1⅓ (1⅓)	2.5 (2.5)	1⅓ (1⅓)

*Values for T-MAX Films are in parentheses.
†Use filter factor of 6 for PLUS-X Pan Professional Film.

Polarizing Filters

You can use polarizing filters in black-and-white and color photography; they do four things: darken blue skies, remove or reduce reflections from nonmetallic surfaces such as water and glass, reduce haze, and increase the saturation of colors.

Polarizing filters work by blocking certain vibrations of light. Light rays not only travel in straight lines, they also vibrate in all directions perpendicular to their direction of travel. When a light ray hits a nonmetallic surface, however, only the vibration in one plane or direction is reflected completely. This reflected light, vibrating in a single plane, is called polarized light.

A polarizing filter is made up of parallel rows of submicroscopic crystals embedded in glass and mounted in a two-ring holder that allows you to rotate it 360°. These rows of crystals allow only light in the plane parallel to the crystals to pass, blocking the remaining light; the effect changes as the filter is rotated. In other words, you can rotate the filter to selectively block out certain rays of reflected light. The nonpolarized light is still transmitted, and this is the light that forms the image on the film.

Some of the reflections a polarizing filter can block out are big and obvious—reflections in a store window, or sunlight reflecting off water. But there are also myriad tiny surface reflections—on leaves and grass—and eliminating these increases color saturation. Also, by removing the reflections from moisture in the atmosphere, a polarizing filter can cut through haze and reveal a darker blue sky. Remember though, reflections from metallic surfaces—polished metal, mirrors, surfaces painted with metallic pigments, etc.—are not polarized and therefore cannot be removed with a polarizing filter.

When you photograph a blue sky with a polarizing filter, the maximum darkening occurs when the sun is at a right angle to your line of sight (shoulder pointing to the sun). The effect diminishes as you turn toward or face directly away from the sun. When the sun is directly overhead, only a small arc of sky near the horizon can be darkened.

Neutral Density Filters

Neutral density filters (also called ND filters) have no color and can be used with both black-and-white and color films. Their main purpose is to reduce the amount of light entering the lens without changing the color of the light. This can have both practical and creative applications. On a practical level, neutral density filters can act like an extra shutter speed or smaller aperture—allowing you to work in very bright light even with relatively fast films. Creatively, neutral density filters allow you to use slower shutter speeds to record the blur of moving subjects, or enable you to select a wider aperture to selectively control depth of field.

Neutral density values are logarithmic and each 0.1 difference changes exposure by ⅓ stop. Thus 0.3, 0.6, and 0.9 represent one, two, and three stop reductions respectively. The filter values are additive and neutral density filters can be used singly or in combination. There are also "split-field" ND filters that have density on only half of the filter and allow you to selectively control the light from one area of a scene—a bright sky or bright sandy foreground, for example. The following table lists the density values of ND Filters and indicates how much each filter reduces exposure.

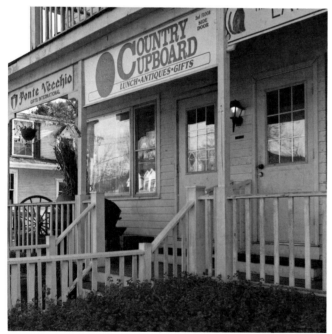

No filter—notice the reflections in the store front window.

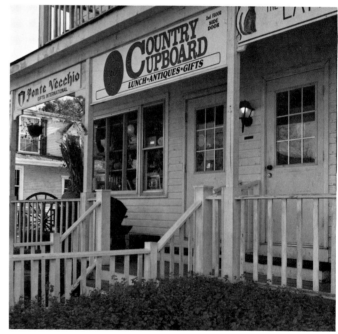

A polarizing filter eliminated the reflections.

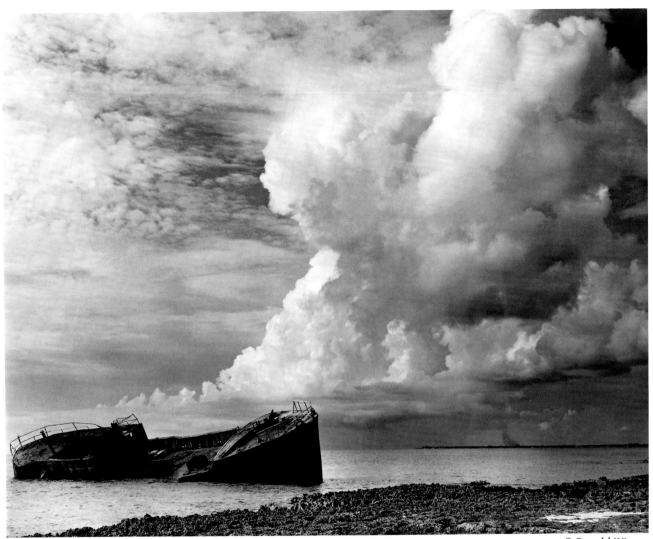

© Ronald Wisner

Ron Wisner used a polarizer in combination with a No. 12 deep yellow filter to reduce the haze and enhance the contrast in this photograph of a shipwreck and passing storm in Grand Cayman, B.W.I.

KODAK WRATTEN Neutral Density Filter No. 96

Neutral Density	Percent Transmission	Filter Factor	Increase in Exposure (Stops)
0.1	80	1.25	⅓
0.2	63	1.5	⅔
0.3	50	2	1
0.4	40	2.5	1⅓
0.5	32	3	1⅔
0.6	25	4	2
0.7	20	5	2⅓
0.8	16	6	2⅔
0.9	13	8	3
1.0	10	10	3⅓
2.0	1	100	6⅔
3.0	0.1	1,000	10
4.0	0.01	10,000	13⅓

More Information on Filters: If you require a complete list of the filters that are available from Kodak, or you need technical data about Kodak filters, refer to KODAK Publication No. B-3, *Handbook of KODAK Photographic Filters.*

© Terry Thibeau/Collins and Associates

9 Close-Up Photography

There is a great sense of wonder and exploration attached to revealing the hidden nuances and unseen mysteries of very small objects with a camera. Whether you're photographing the intricate circuits etched into the surface of a computer chip or a raindrop on a blade of grass, you'll find that close-ups can reveal aspects of the subject that would normally go unseen. And the view camera, with its simple lens-bellows-film design, is perhaps the most flexible of all close-up photography tools. Your explorations are restricted only by the resolving power of your lens, the limitations of your bellows extension, the steadiness of your camera stand or tripod—and the boldness of your curiosity.

Magnification

Close-up, ultra close-up, and macro photography are all terms used to describe the photography of small objects. Though arbitrary lines of division are frequently drawn between these different categories (based on the degree of subject magnification), all can be loosely grouped under the heading of photomacrography. Photomacrography usually involves using simple optical systems (i.e. cameras) to make images ranging from just under life-size to about 25X life size. Magnifications beyond 25X generally exceed the limitations of most standard photographic equipment and are best made with the help of a microscope (photomicrography).

The most important thing to remember in planning a photomacrograph is that as you move the camera closer to the subject, you must move the lens farther from the film plane to keep the subject in focus. Bellows extension, therefore, becomes a critical factor in establishing the

An additional support frame, a double bellows extension, and an extra-length rail, provide enough bellows draw for photomacrography.

limits of magnification for a particular lens and subject combination. You achieve life-sized reproduction, for example, only when both the subject and the ground glass are at twice the lens' focal length from the lens. In other words, if you're working with a 10-inch lens, the subject plane and the film plane must each be 20 inches from the lens. If bellows limitations restrict magnification and no extensions are available, you can switch to a shorter focal length lens (which requires less extension), but this requires moving even closer to the subject and will change the perspective.

Magnification (or, in the case of smaller-than-life-size images, reduction) in a close-up photograph is described numerically—either as a whole number or a fraction of a whole number. Numbers less than 1 (such as

0.5X) indicate that the image is smaller than the subject, while numbers greater than 1 indicate that the image size is larger than the subject (2X, 3X, etc). These same magnifications can also easily be expressed as ratios. A ratio of 1:1, for instance, is life-sized; 2:1 is a 2X magnification, 1:2 is half life-size and so on.

You can use a simple lens formula to calculate the maximum scale of reproduction that's possible with a given camera and lens combination: $R = (v-f)/f$, where R is the scale of reproduction, v is the image distance (lens to film distance), and f is the focal length of the lens. Thus, a view camera with a 16-inch maximum bellows extension equipped with a 4-inch lens could produce a 3-to-1 maximum scale of reproduction:

$$R = (16-4)/4 = 12/4 = 3.$$

Elegant design and sparkling detail are the essence of this close-up shot. The photo was created for a catalog assignment and made on KODAK T-MAX 100 Professional Film by Terry Thibeau of Collins and Associates.

Adjusting Exposure

As the lens is moved further from the film plane, the light is spread over a larger area, reducing its intensity. To compensate for the reduced intensity, you must increase exposure. Although this light loss is negligible within the normal focusing range, with close-up photography it can become a significant factor. Also, while the marked *f*-stop ratio remains accurate for distant subjects, there is a point beyond the infinity focus position where the effective value of the lens openings is reduced.

As a general rule, you should adjust exposure whenever the subject is about eight focal lengths or closer to the lens. For example, a 300 mm (12 inch) lens requires an exposure increase anytime you're closer than eight feet. Another guideline calls for exposure compensation when the total bellows extension (focal distance) exceeds approximately 1.3 times the focal length of the lens you're using. Additional exposure isn't required if you are using a behind-the-lens metering system—or when the close focusing is done with a supplementary close-up lens. (See page 90.)

The exact amount of the increased exposure depends on the lens-to-film distance. This distance (sometimes called bellows extension), is commonly measured from the film plane to the plane of the lensboard or the lens diaphragm. This assumes that the position of the lensboard (or diaphragm) corresponds with the rear nodal point of the lens—which isn't always the case. As we mentioned earlier, for example, the rear nodal point of a true telephoto lens is not in the body of the lens itself, but in front of the lens (see page 34). To determine the exact location of the rear nodal point for such a lens, focus the lens on infinity and then measure the distance of the lens' focal length forward from the exact plane of the ground glass. You must also consider this additional distance in front of the lens when determining the actual lens-to-film distance.

Calculating the Exposure Increase Factor: The easiest way to calculate the amount of correction needed to compensate for bellows extension is to use the Close-Up Exposure Dial in the *KODAK Professional Photoguide*, KODAK Publication No. R-28. This computation guide indicates both exposure time and lens aperture adjustments. Or, you can use the following simple formula that calculates an exposure or "bellows factor" that is directly related to the square of the bellows extension divided by the square of the focal length.

$$\text{Exposure Factor} = \frac{(\text{Bellows extension})^2}{(\text{Focal Length})^2}$$

OR:

$$\text{Exposure Factor} = \left(\frac{\text{Bellows extension}}{\text{Focal length}}\right)^2$$

You can use the exposure factor derived from this formula to increase exposure either by changing the lens opening or the shutter speed. In situations where depth of field is already minimal, it's better to use a longer exposure and maintain the same aperture. Where subject motion might be a problem it may be better to use a larger aperture and keep the same shutter speed.

To alter the exposure time using the factor, multiply the factor by the shutter speed. A quick way to do this mentally is to simply make a fraction using the factor as the top half and the shutter speed as the bottom, then divide both by the factor. If you're working at a speed of 1/250 second and your calculated factor is 2, for instance, the new shutter speed will be: 2/250 (2/1 x 1/250) or 1/125 second. To increase the aperture by a factor of 2, you would open up one stop (remember that each larger stop equals a doubling of the light intensity); to increase the aperture by a factor of 4, open the lens two stops, etc. Remember too, if the added exposure time is abnormally long, it may require additional exposure time to compensate for reciprocity effect (see page 56).

To isolate the subject (a key), and show the necessary detail, a single mini-spotlight and a white card provided the main and fill lights. Another card between the key and the spotlight blocked light from the background (below the key).

A 75 mm (3-inch) lens with an extension of 15 inches produced a 4X magnification. The required exposure increase factor was 25 (M plus one, squared).

Alternative Exposure Calculations:

Another technique used for calculating the necessary exposure correction involves computations based on magnification ratio (the ratio of the image size to the object size). The most direct way to determine magnification is to measure some dimension on the subject itself, then measure the corresponding image dimension on the ground glass. The magnification can then be found by dividing the image size by the object size: $M = I/O$.

Or you can use one of these formulas—related to the lens-to-film and lens-to-subject distances and focal length—to figure magnification.

$$\text{Magnification} = \frac{\text{Lens-to-film distance}}{\text{Lens-to-subject distance}}$$

OR:

$$M = \frac{\text{(Lens-to-film distance)} - \text{(Lens focal length)}}{\text{Lens focal length}}$$

OR:

$$M = \frac{\text{Lens focal length}}{\text{(Lens-to-subject distance)} - \text{(Lens focal length)}}$$

With the magnification known, you can calculate the exposure increase factor using the following formula:

$$\frac{\text{Exposure}}{\text{increase factor}} = (\text{Magnification} + 1)^2$$

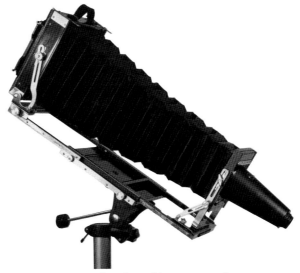

An extension lens board for extreme close-ups.

For example, assume that you're using a 150 mm lens with an extension (lens-to-film distance) of 300 mm and the indicated exposure is $f/16$ at 1/60 second.

First: Determine the magnification

$$M = \frac{(300 \text{ mm} - 150 \text{ mm})}{150 \text{ mm}} \text{ or } M = 1$$

Then:

$$\frac{\text{Exposure}}{\text{factor}} = (M + 1)^2 = (1 + 1)^2 = 4$$

Correcting the meter-indicated aperture of $f/16$ by a factor of 4 requires opening the lens by two stops (from $f/16$ to $f/8$). The same factor can also be used to adjust exposure time: $4/1 \times 1/60 = 4/60$ or $1/15$ (an increase in exposure time of two stops).

Close-Up Attachments

Positive (+) supplementary lenses, or close-up attachments, provide a useful and relatively inexpensive way of getting a larger image by effectively reducing the focal length of the camera lens and thereby reducing its close-focusing distance. When positive supplementary lenses are used for close-up photography, the *f*-values marked on the camera lens can be used directly with no exposure compensation.

You thread supplementary lenses onto the front of the lens like a filter; they are usually described by their power in diopters (+1, +2, +3). The higher the number, the stronger the lens and the closer you can get to the subject. The numbers are additive, so you can use two supplementary lenses together to increase the magnifying power and to work at even closer distances. For example, a +2 lens and a +3 lens equals a +5 lens. When using two lenses together, place the stronger of the two closer to the camera lens. However, do not use more than two supplementary lenses—image quality may suffer dramatically and the image may be cut off at the corners.

When the camera lens is focused at infinity and a supplementary lens is used, the lens-to-subject distance is equal to the focal length of the supplementary lens. This is true regardless of the focal length of the camera lens. To determine the focal length of the supplementary lens, form a fraction by placing 1 over the power (diopter). The focal length of the supplementary lens is that fraction of a meter. When using two supplementary lenses together, add their powers before forming the fraction.

Controlling the plane of sharpness becomes especially critical when working at close range where the depth of field is very shallow. Photo made by Xenophon Beake on 4 x 5-inch KODAK PLUS-X Pan Professional Film.

Lens Power	Focal Length
+1	1 m = 1000 mm
+2	½ m = 500 mm
+3	⅓ m = 333 mm
+4	¼ m = 250 mm
+5	⅕ m = 200 mm

For optimum sharpness when using a supplementary lens, stop the camera lens down to *f*/8 or *f*/11. As with all close-up work, the depth of field when using positive supplementary lenses is very shallow. Therefore, be sure to examine the ground glass image carefully from center to edge for sharpness and evenness of illumination.

Photograph by Michael Ruppert on 4 x 5-inch KODAK PLUS-X Pan Professional Film.

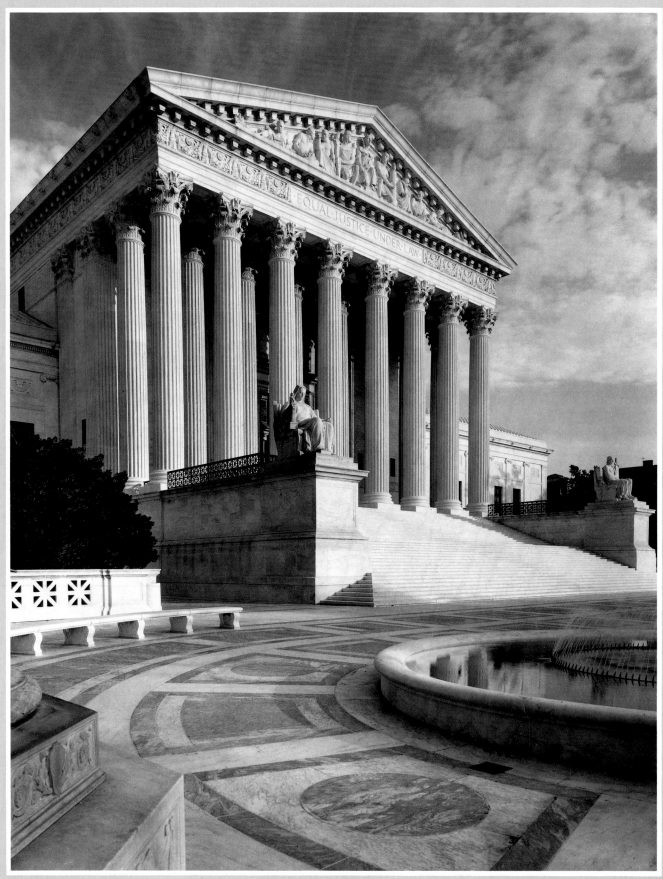

Norm Kerr

Appendix

Sequence of View Camera Operations

The following is a typical step-by-step process of setting up the camera, framing the subject, focusing the subject, and exposing the film. The exact sequence may vary depending on the camera and the requirements of the subject, but these steps are representative of how an image is produced with a large-format camera.

1. **Perspective:** Position yourself so that the size relationships of the front and back parts of the subject give you the size relationships you will need in the completed photograph.

2. **Frame the Subject:** Center the image on the ground glass. A focusing hood or viewer will be necessary to block extraneous room light so you can see the ground glass clearly.

3. **Focus the Camera:** You can focus by moving the front or the rear standard. However, by adjusting the back instead of the lens board, the lens-to-subject distance remains unchanged and the image size on the ground glass is not affected. This is particularly useful when doing close-ups where even a slight movement of the lens can dramatically alter the subject size.

4. **Check for Coverage:** Position the camera for the proper perspective and make certain that the lens covers enough of the subject from side to side and top to bottom. Also check to see if there is too much coverage (the subject occupies only a small portion of the negative). If you must change the framing, select another lens that will give you the proper coverage and image size.

5. **Refocus:** If you changed to a different lens, then refocus.

6. **Adjust Image Size:** At this point, it may be necessary to adjust the image size slightly by moving the camera either closer to or farther from the subject. If a major adjustment is needed, move the entire tripod. For minor adjustments, slide the camera rail backward or forward in its tripod mount. This moves the camera without the difficulties caused by moving the tripod.

7. **Make Corrections:** To correct shape distortion, swing or tilt the camera back.

8. **Recenter the Image:** If available, use the camera back lateral shift or rise movements to recenter the image; if the rear adjustments are not available and it is necessary to use the front movements, check for any change in the image size.

9. **Adjust Zone of Sharpness:** If depth is insufficient, swing or tilt the lens to position the zone of sharpness to include the important areas of the subject.

10. **Additional Sharpness Adjustment:** If distortion is no problem and it is not possible to swing or tilt the lens enough to precisely position the zone of sharpness, you may also use the back adjustments to aid in this positioning.

11. **Refocus:** Using the rear standard, refocus the image to more precisely position the zone of sharpness.

12. **Exposure Calculation:** Using an exposure meter, determine the correct exposure. Reflected readings of the brightest highlight and darkest shadow can determine the contrast range. An incident-light reading can provide the average illumination level to calculate the basic exposure.

13. **Exposure Increase:** For close-up work, calculate the exposure increase needed because of the bellows extension.

14. **Check Depth of Field:** Stop the diaphragm down to the working aperture while checking the ground glass to make certain there is sufficient depth of field. A magnifying loupe will be necessary to see the image clearly.

15. **Examine Ground Glass:** Check the four corners of the ground glass for vignetting to be certain the bellows does not intrude into the picture area. Also check to make sure that nothing extraneous to the picture is visible on the ground glass. If it is, remove it.

16. **Set Shutter Speed and Cock Shutter:** Close the shutter. Set the shutter speed for the correct exposure based on the selected aperture setting. Cock the shutter. Keep in mind that in situations where subject movement calls for a high shutter speed, you must either provide more light on the subject or make a compromise in the depth of field by using a larger aperture.

17. **Exposure Test:** Insert an instant print film back for making a test to check the exposure, lighting, and composition. Be certain all camera and tripod screws are firmly tightened to avoid shifting the focus when pulling out the spring back. After making the exposure, some photographers remove the film back from the camera before pulling the film tab to begin development of the instant print material. This avoids disturbing the camera setup.

18. **Insert Film Holder:** If satisfied with the test results, insert the film holder.

19. **Remove Dark Slide:** Check the lens to be certain it has been closed, then pull the dark slide from the holder.

Taking advantage of the film's ability to record fine detail, Norm Kerr used KODAK T-MAX 100 Professional Film for this photograph of the U.S. Supreme Court building.

20. **Stop:** Wait for any vibrations or movements of the camera to subside.

21. **Make the Exposure:** Always use a cable release to actuate the shutter. Pressing the shutter-release button by hand can generate enough movement to degrade the razor-edge sharpness that is possible with a view camera.

22. **Replace Dark Slide:** Always replace the dark slide immediately after exposing the film. Accidentally pulling the holder out of the camera before reinserting the dark slide accounts for many ruined films.

23. **Lock It:** Turn the latches on the end of the film holder to make certain the slide is not accidentally pulled out.

24. **Check Slide:** In replacing the dark slide, be certain that the black side is facing out. This indicates exposed film. It is easy to become confused and make a second picture on the same piece of film if you neglect this procedure.

25. **Advance Film:** When using a roll-film holder, advance the film immediately after making the exposure so there is no danger of making a double exposure.

26. **Check Focus:** Remove the holder, open the camera shutter and diaphragm, and recheck the focus to make certain it did not shift while you were manipulating the camera.

Index